高橋和希　遊☆戯☆王 イラスト集

DUEL ART

Kazuki Takahashi Yu-Gi-Oh! illustrations

MONSTER

Dragons, demons, magicians, swordsmen, and even gods;
these monsters cover the whole spectrum. As a duelist's
soldiers, they can portend either destruction or
redemption, reflecting the truths of human nature.

Monster

— 1 —

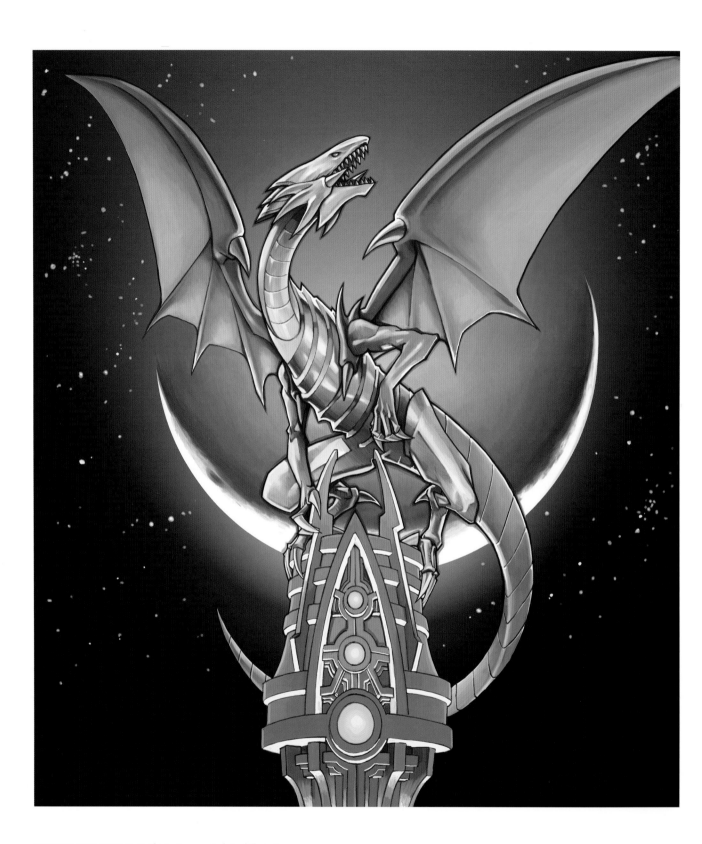

DECEMBER 20TH, 2008: Yu-Gi-Oh! Anniversary Pack Card Illustration

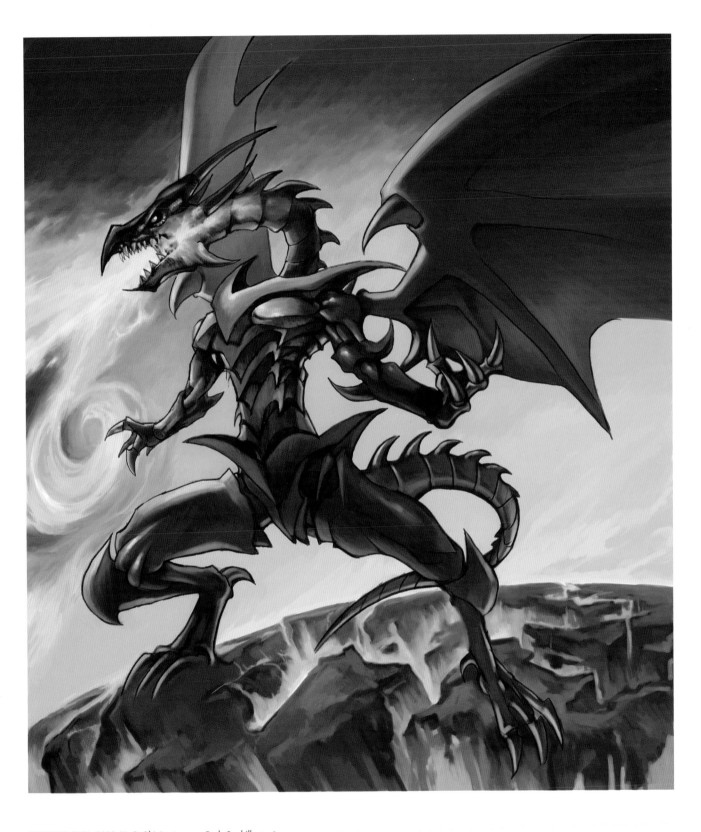

DECEMBER 20TH, 2008: Yu-Gi-Oh! Anniversary Pack Card Illustration

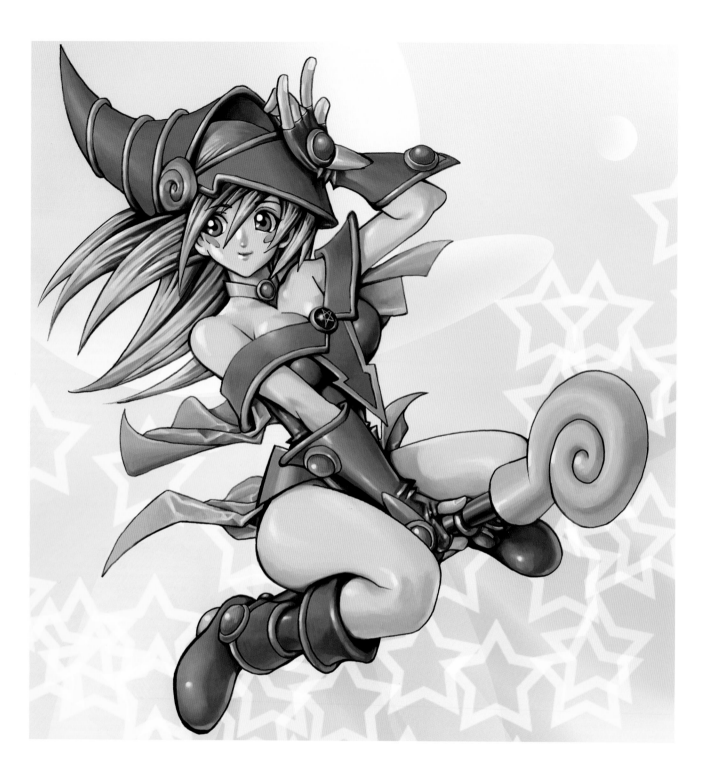

DECEMBER 20TH, 2008: Yu-Gi-Oh! Anniversary Pack Card Illustration

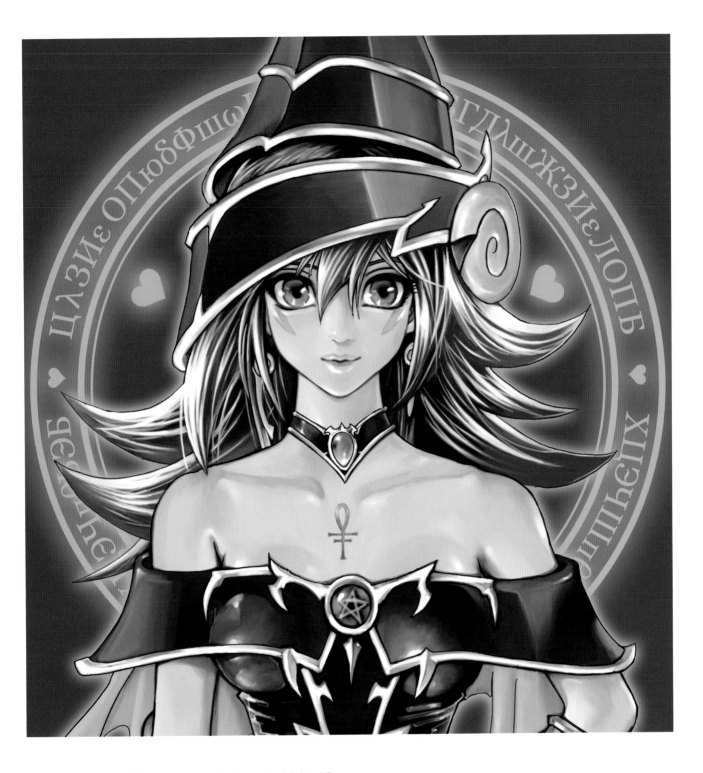

DECEMBER 12TH, 2011: Weekly Shonen Jump New Year Issue #2 Included Card Illustration

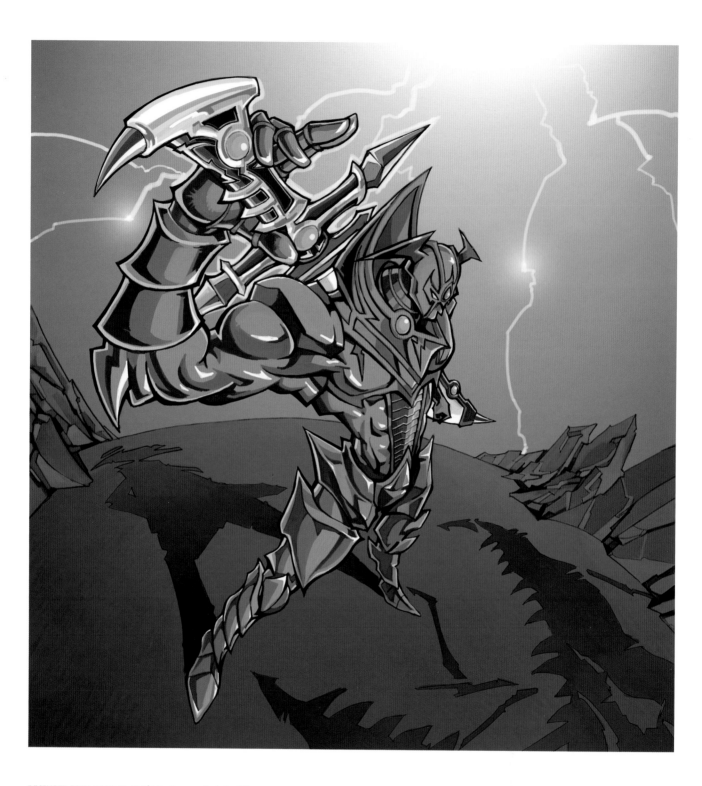

DECEMBER 20TH, 2008: Yu-Gi-Oh! Anniversary Pack Card Illustration

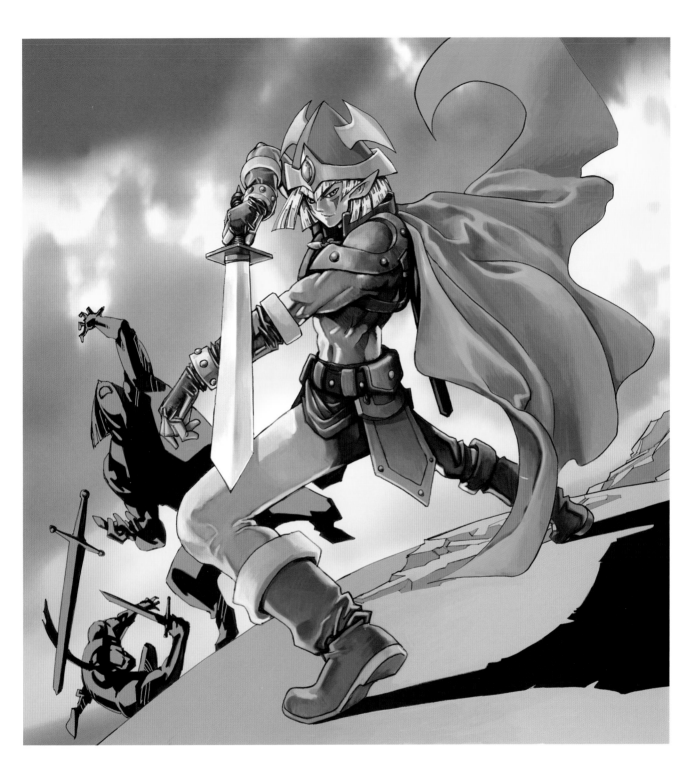

DECEMBER 20TH, 2008: Yu-Gi-Oh! Anniversary Pack Card Illustration

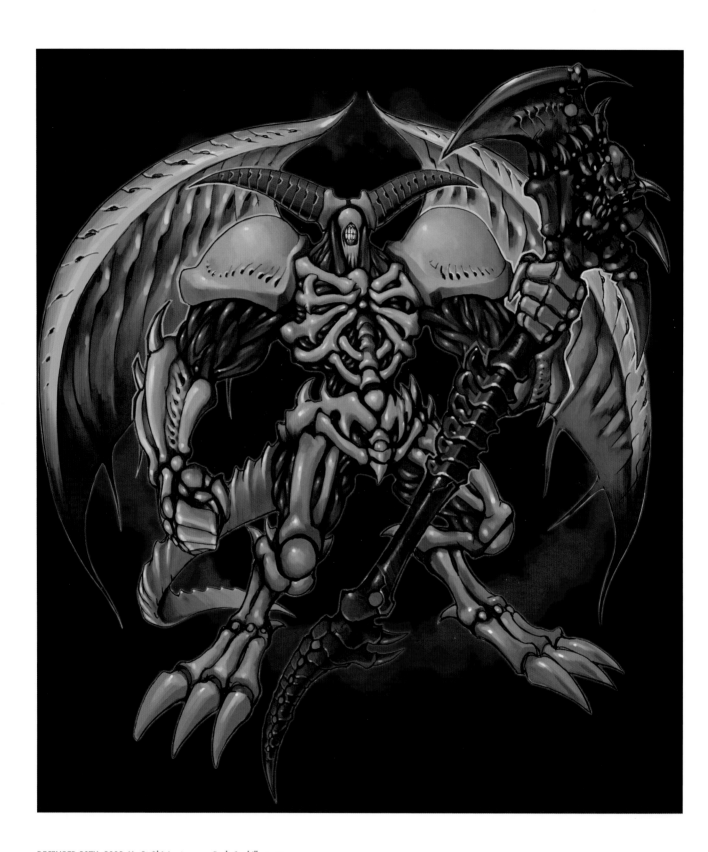

DECEMBER 20TH, 2008: Yu-Gi-Oh! Anniversary Pack Card Illustration

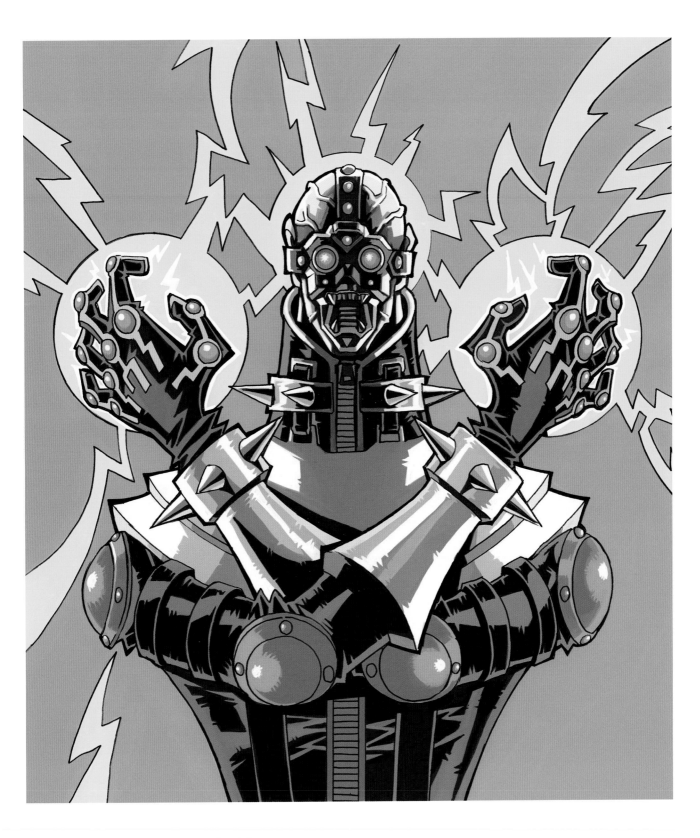

DECEMBER 20TH, 2008: Yu-Gi-Oh! Anniversary Pack Card Illustration

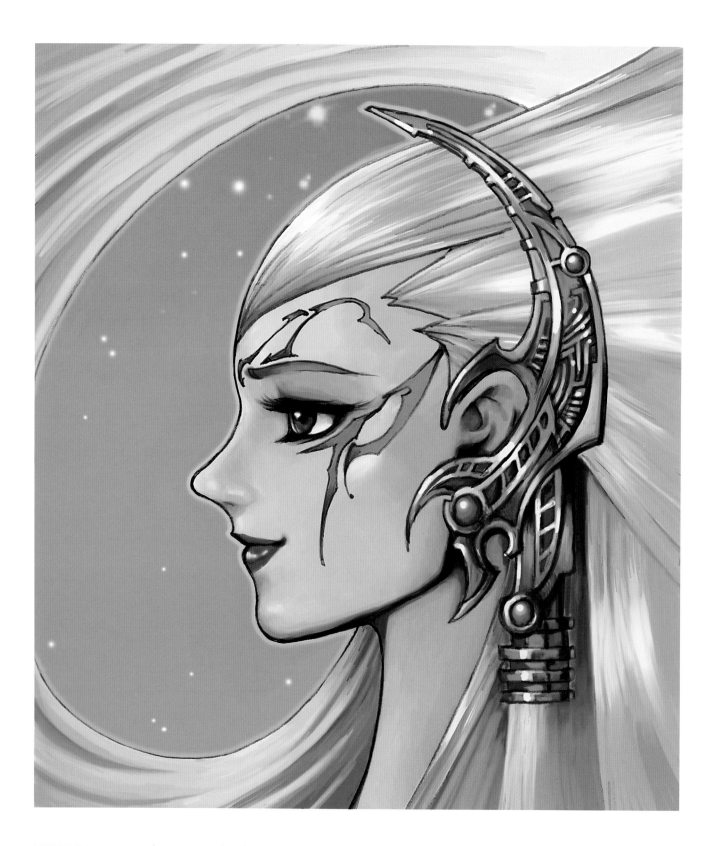

DECEMBER 20TH, 2008: Yu-Gi-Oh! Anniversary Pack Card Illustration

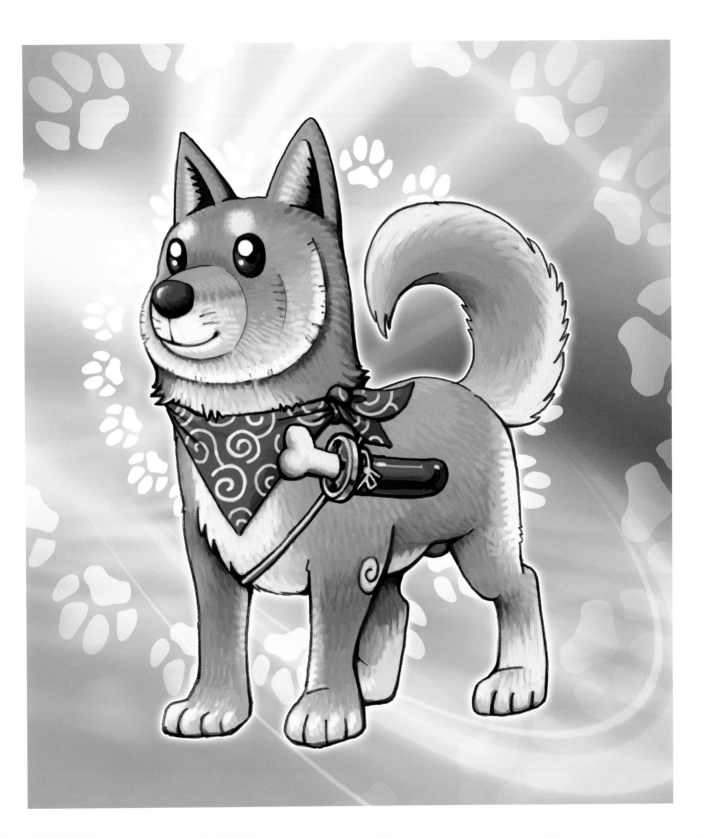

DECEMBER 20TH, 2008: Yu-Gi-Oh! Anniversary Pack Card Illustration

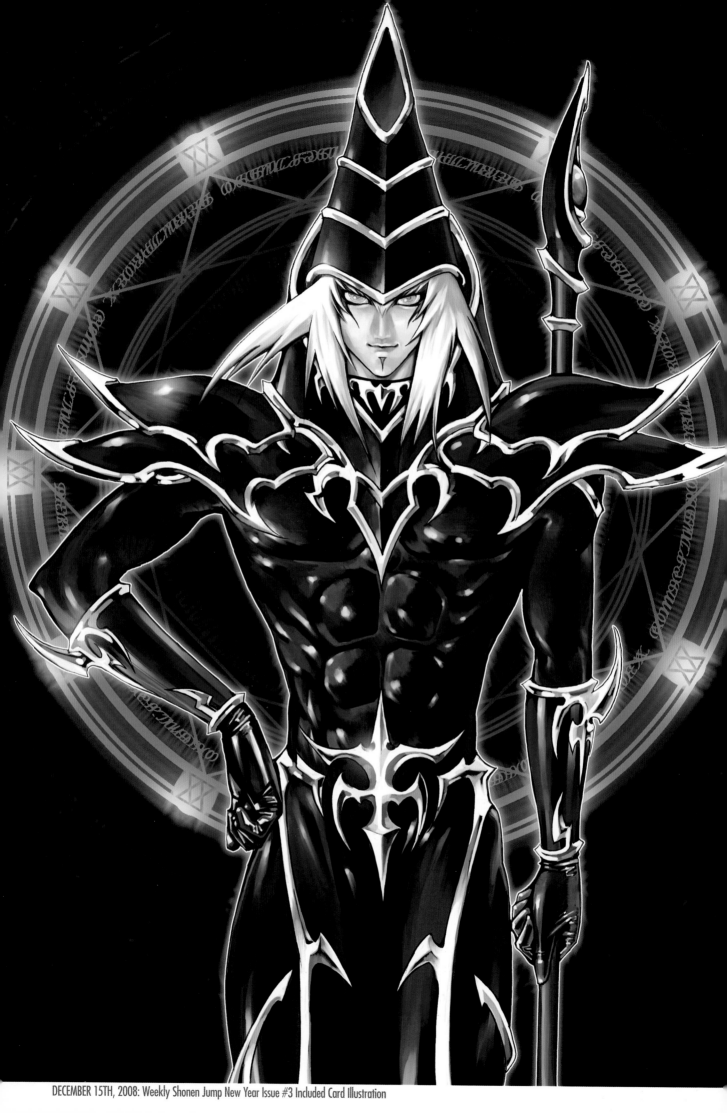

DECEMBER 15TH, 2008: Weekly Shonen Jump New Year Issue #3 Included Card Illustration

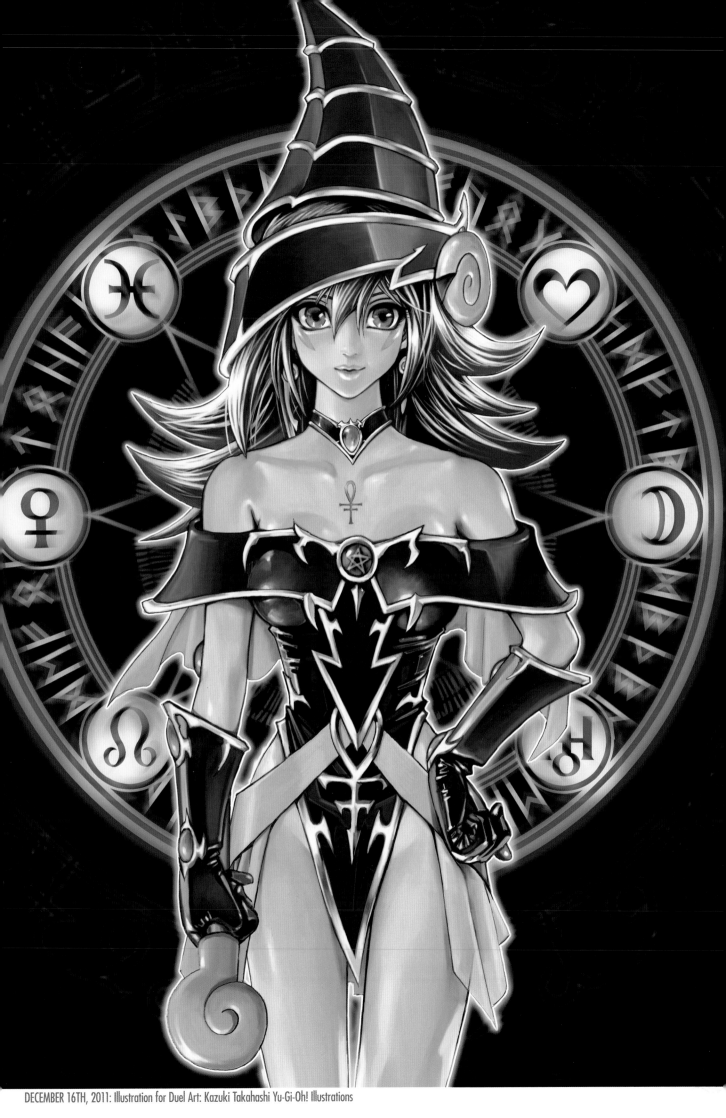

DECEMBER 16TH, 2011: Illustration for Duel Art: Kazuki Takahashi Yu-Gi-Oh! Illustrations

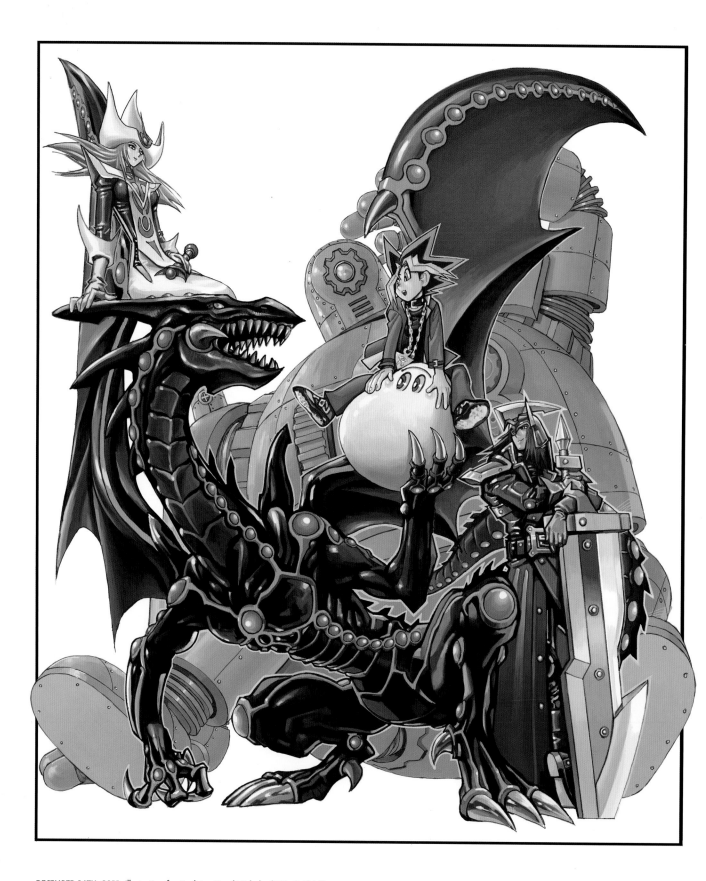

DECEMBER 16TH, 2011: Illustration for Duel Art: Kazuki Takahashi Yu-Gi-Oh! Illustrations

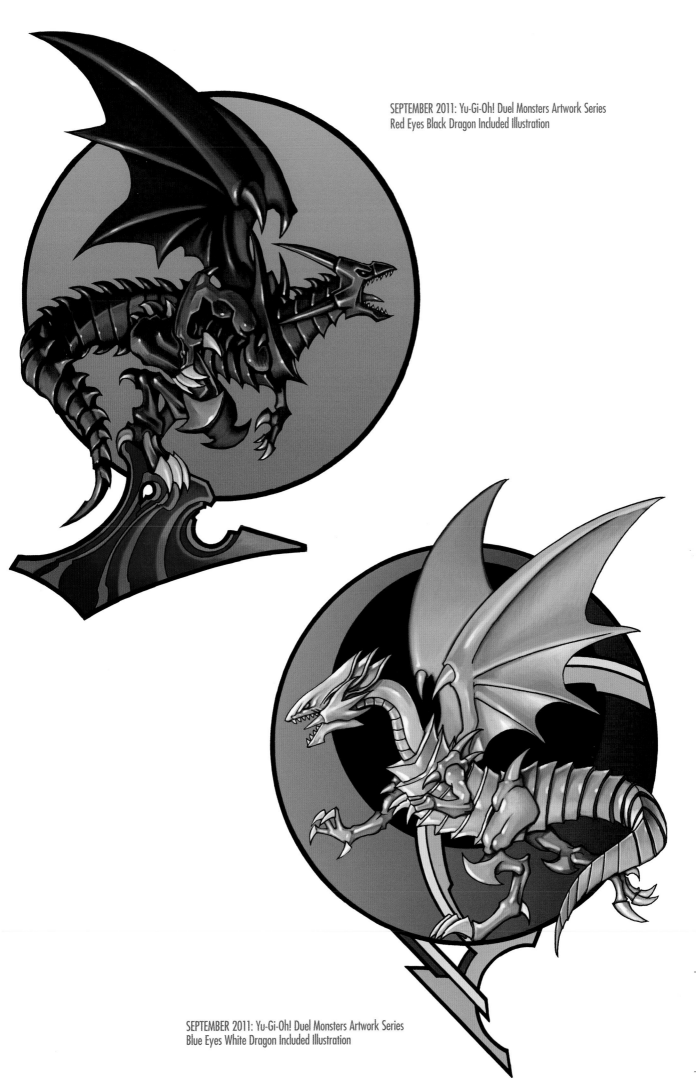

SEPTEMBER 2011: Yu-Gi-Oh! Duel Monsters Artwork Series
Red Eyes Black Dragon Included Illustration

SEPTEMBER 2011: Yu-Gi-Oh! Duel Monsters Artwork Series
Blue Eyes White Dragon Included Illustration

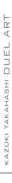

DECEMBER 20TH, 2008: V-Jump February Jumbo Issue Included Card Illustration

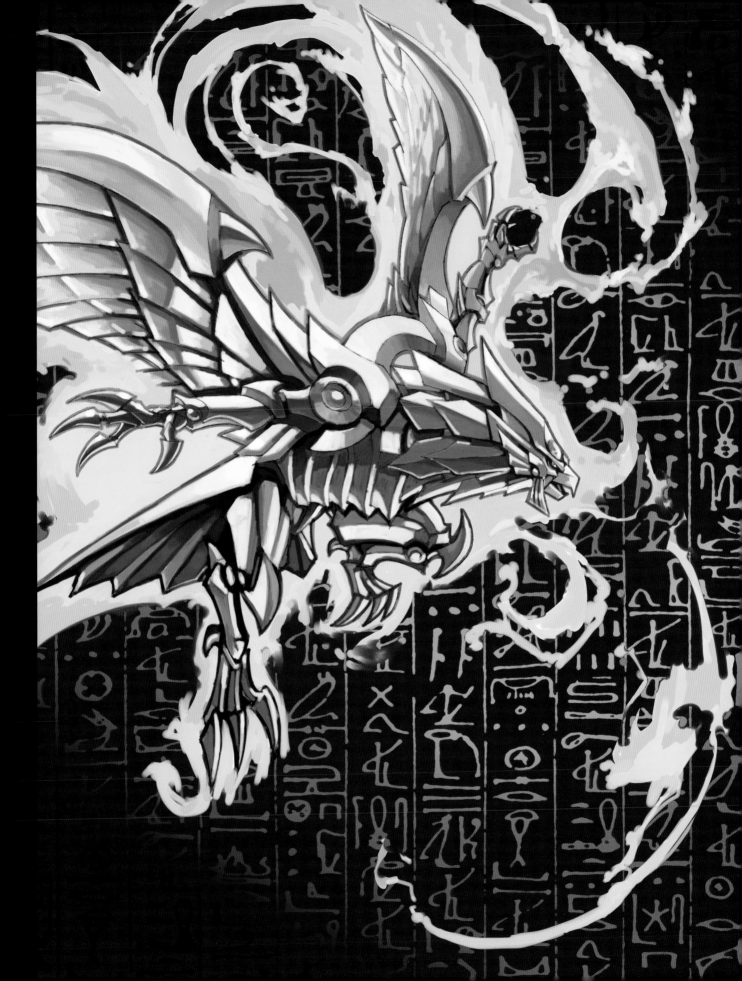

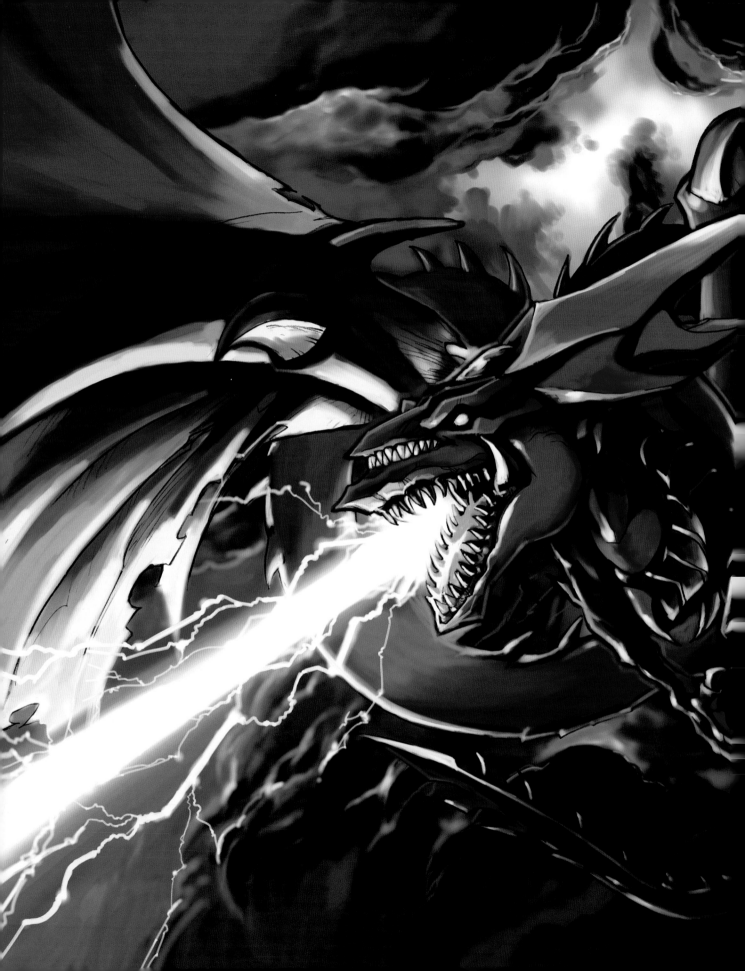

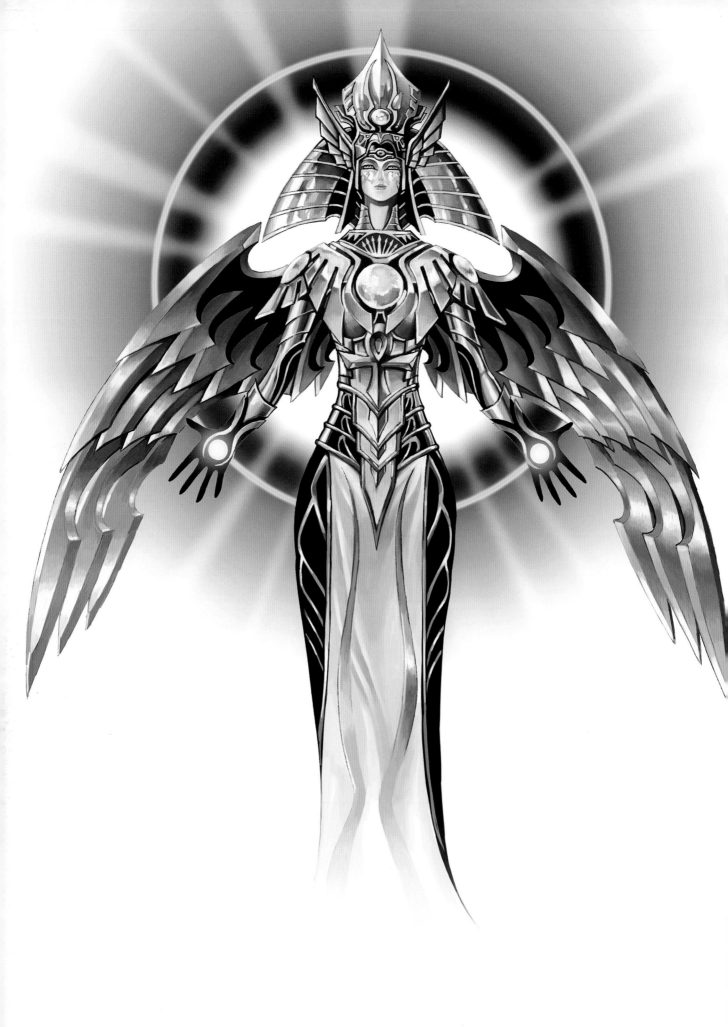

DECEMBER 16TH, 2011: Duel Art: Kazuki Takahashi Yu-Gi-Oh! Illustrations: Compiled Illustration

FUTURE

The true essence of a "game" reveals the gap between people and their clashing wills. "Yu-Gi-Oh!" never loses that essence, even as the story moves through the future and jumps between different worlds, dimensions, and realities.

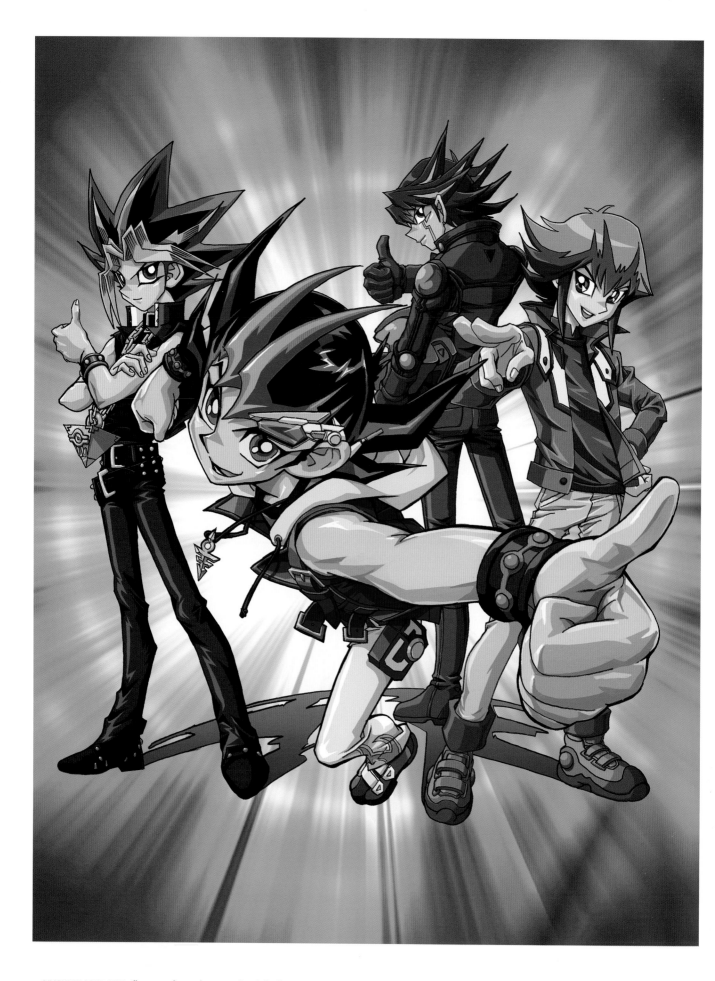

DECEMBER 16TH, 2011: Illustration for Duel Art: Kazuki Takahashi Yu-Gi-Oh! Illustrations

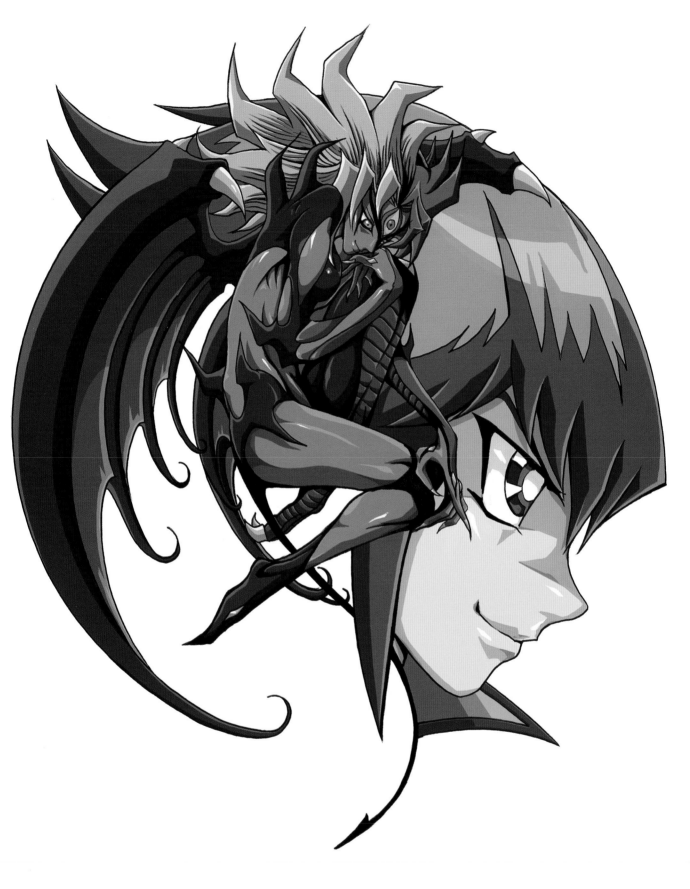

DECEMBER 16TH, 2011: Illustration for Duel Art: Kazuki Takahashi Yu-Gi-Oh! Illustrations

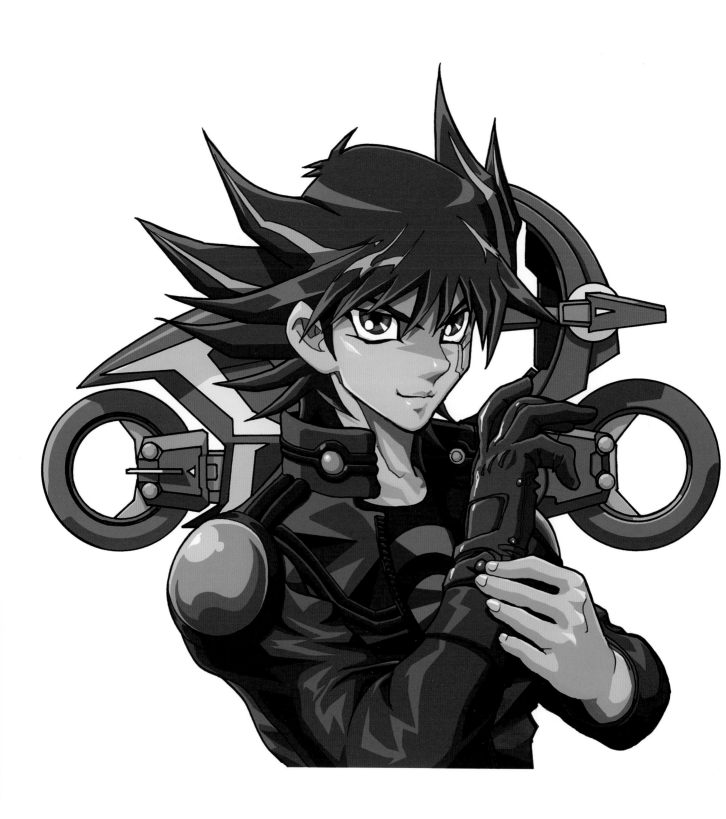

DECEMBER 16TH, 2011: Illustration for Duel Art: Kazuki Takahashi Yu-Gi-Oh! Illustrations

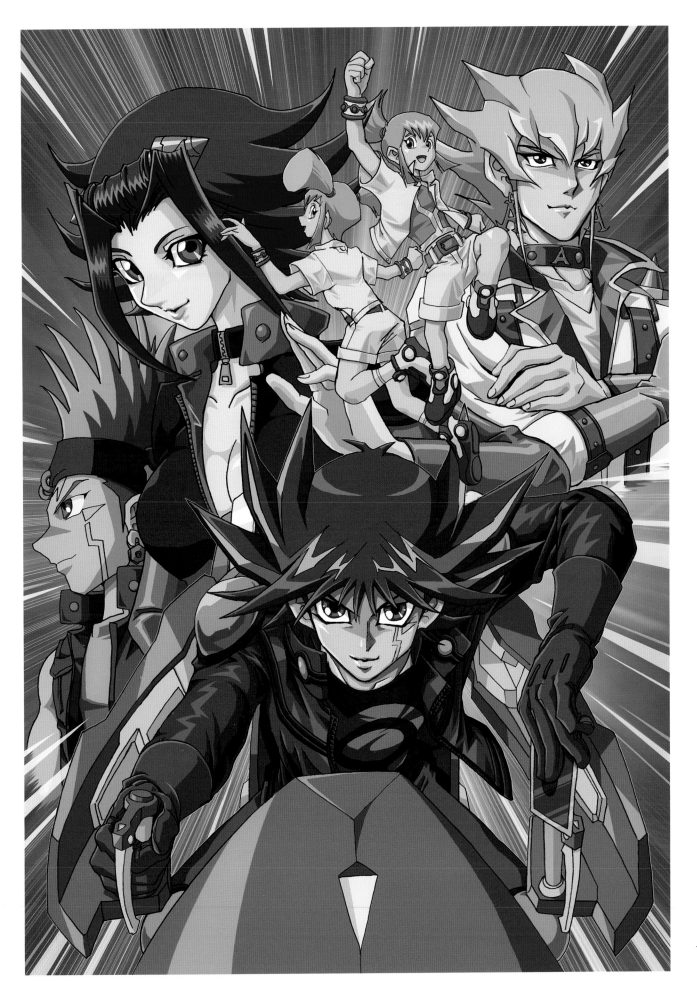

DECEMBER 16TH, 2011: Illustration for Duel Art: Kazuki Takahashi Yu-Gi-Oh! Illustrations

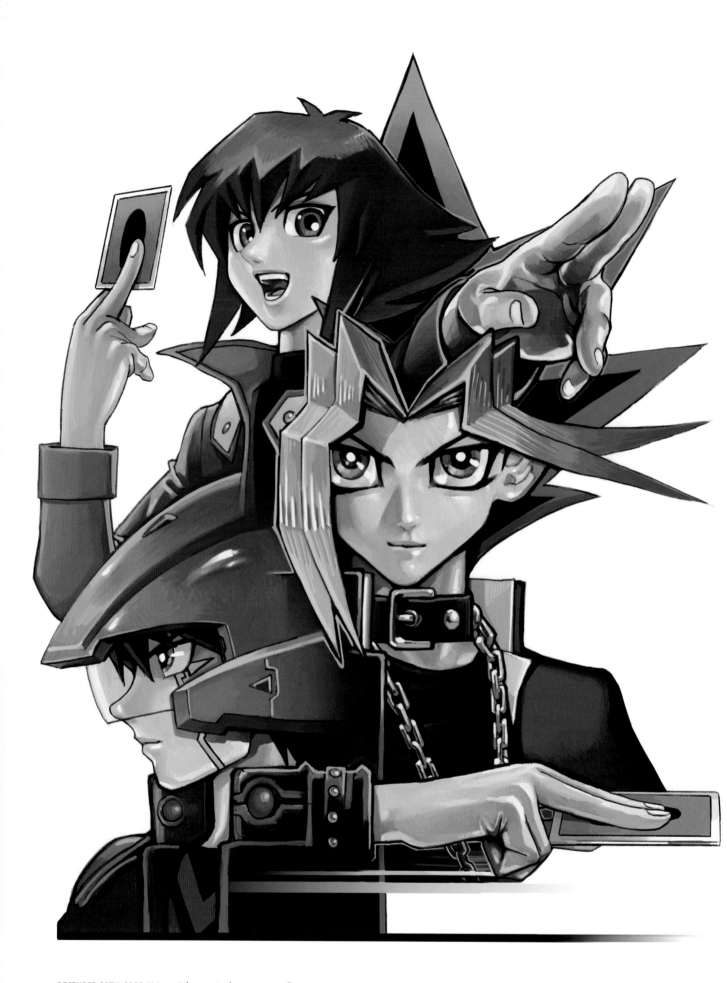

DECEMBER 20TH, 2008: V-Jump February Jumbo Issue Cover Illustration

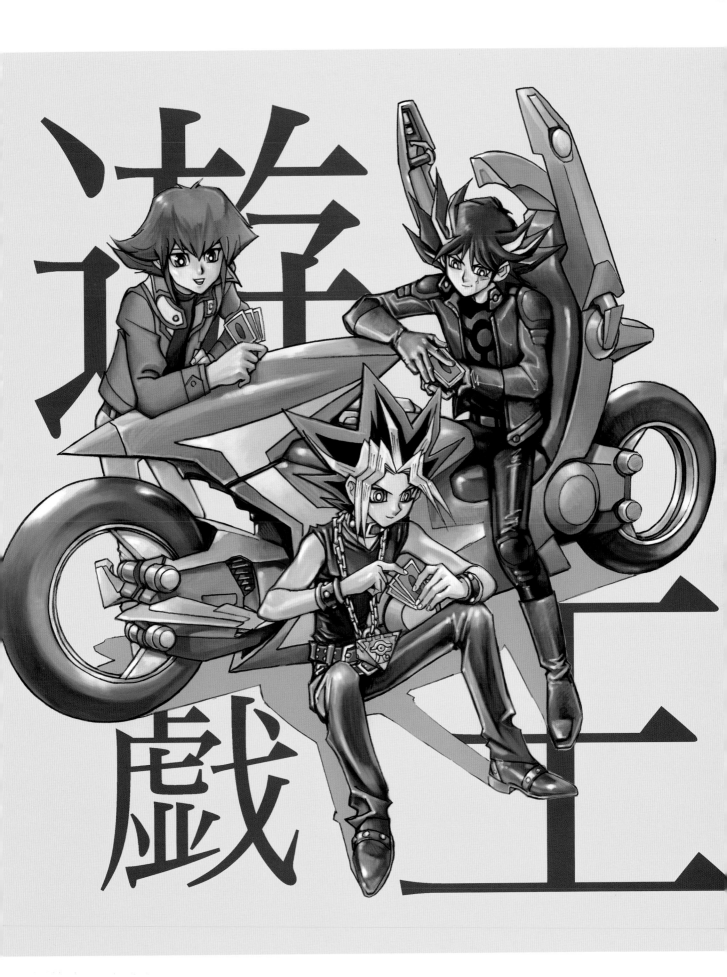

DECEMBER 19TH, 2009: V-Jump February Jumbo Issue Cover Illustration
Background translation: "Yu-Gi-Oh!"

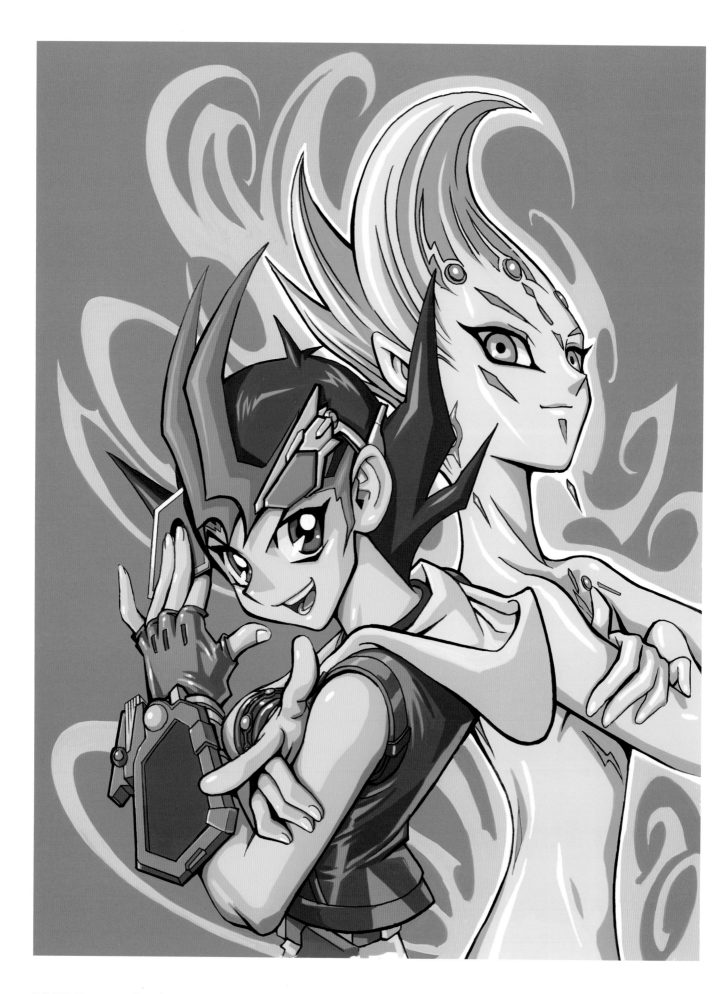

MAY 21ST, 2011: V-Jump July Jumbo Issue Cover Illustration

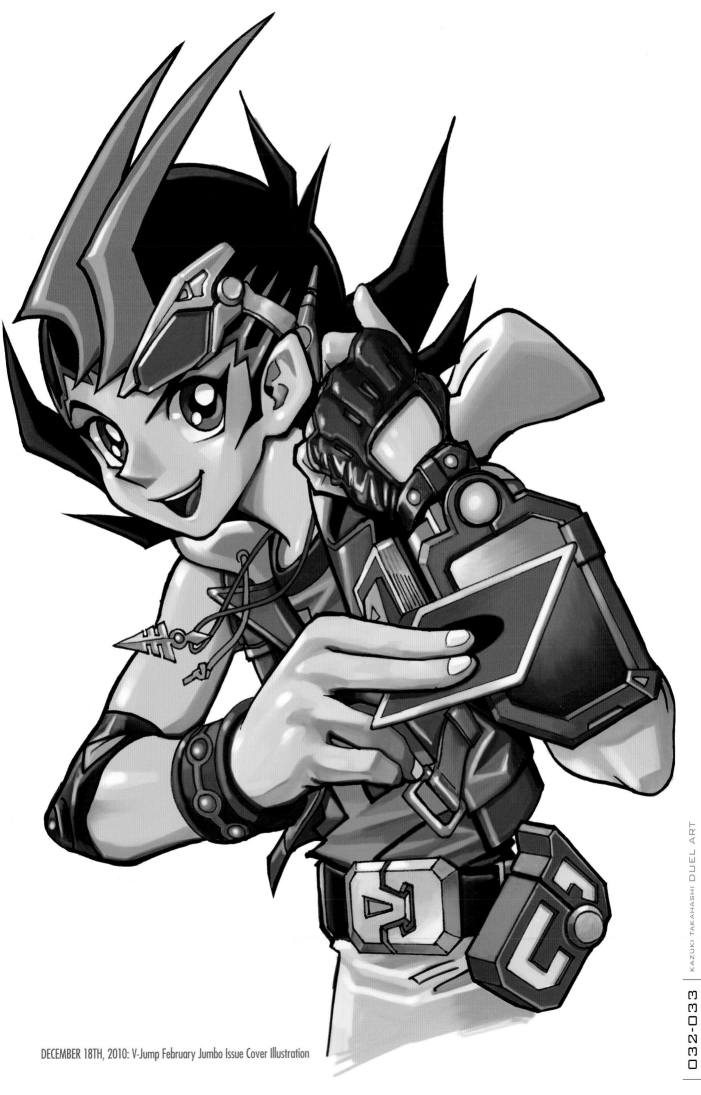

DECEMBER 18TH, 2010: V-Jump February Jumbo Issue Cover Illustration

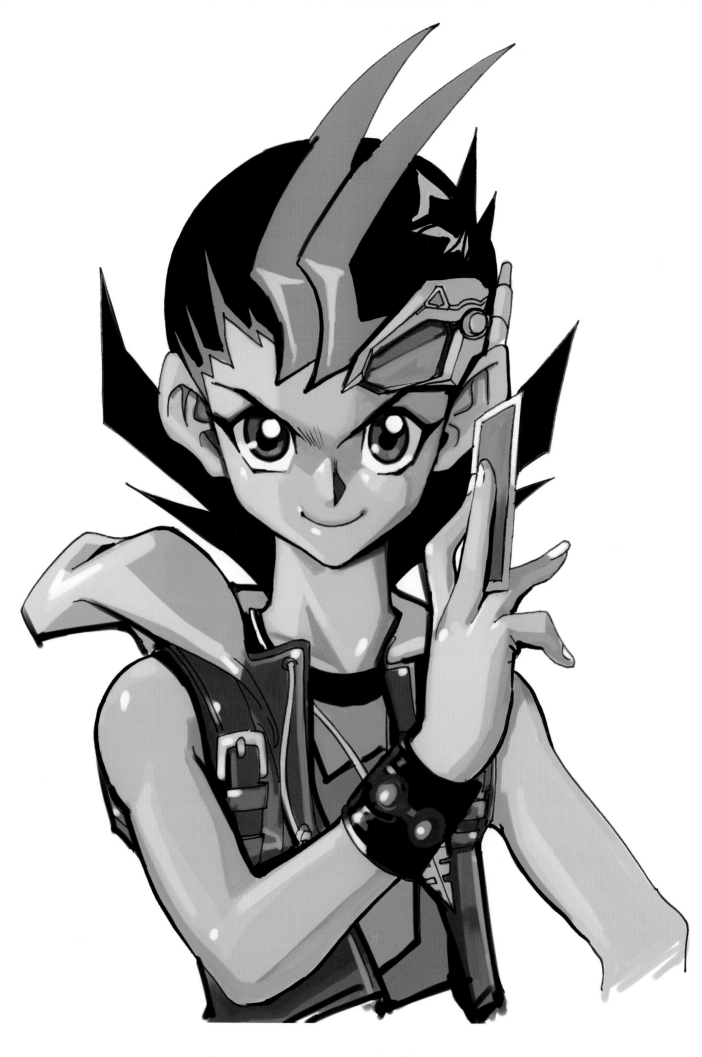

DECEMBER 16TH, 2011: Duel Art: Kazuki Takahashi Yu-Gi-Oh! Illustrations: Compiled Illustration

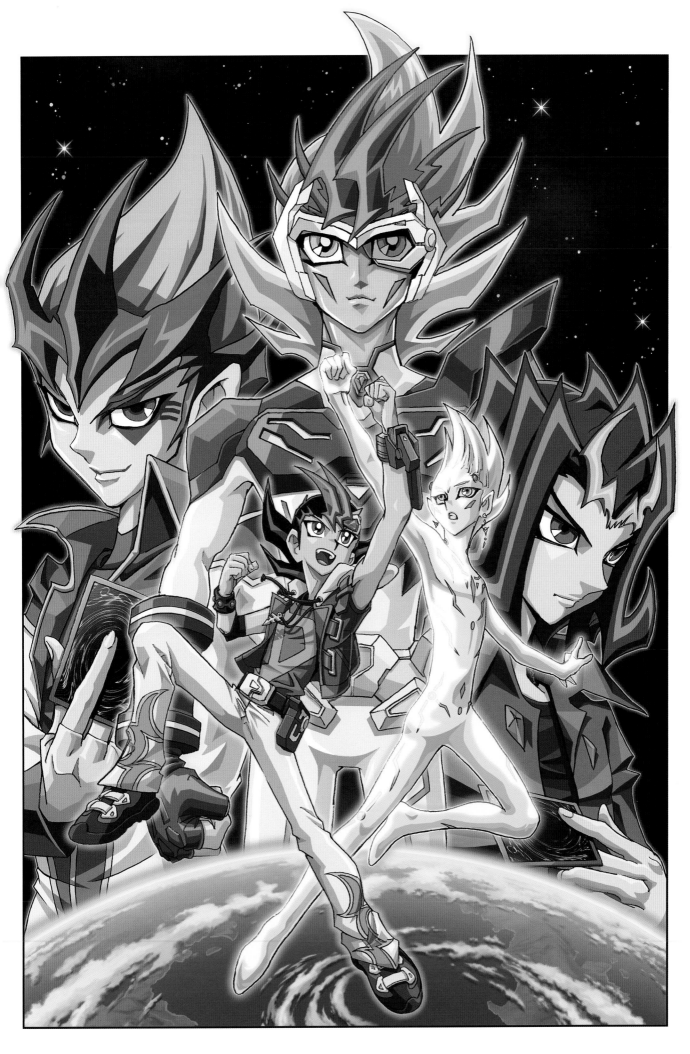

DECEMBER 16TH, 2011: Illustration for Duel Art: Kazuki Takahashi Yu-Gi-Oh! Illustrations

ZEXAL

Yu-Gi-Oh! ZEXAL

AIRED FROM APRIL 11TH, 2011 TO SEPTEMBER 24TH, 2012

With his signature phrase "Feeling the flow!", duelist Yuma Tsukumo takes on every challenge he comes across. With the help of the mysterious spirit Astral, he aims to become a duel champion.

5D'S

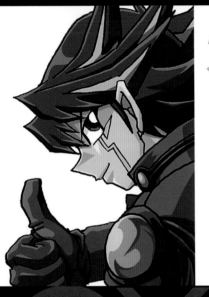

Yu-Gi-Oh! 5D's

AIRED FROM APRIL 2ND, 2008 TO MARCH 30TH, 2011

Duelists bearing the "mark of the dragon" must join together and forge bonds in order to defeat a great evil that threatens New Domino City...

GX

Yu-Gi-Oh! GX

AIRED FROM OCTOBER 6TH, 2004 TO MARCH 26TH, 2008

GX is set at Duel Academy and centers on the ever-cheery Jaden Yuki, whose love of dueling knows no equal. The story portrays his matches against powerful foes and follows his growth as a person.

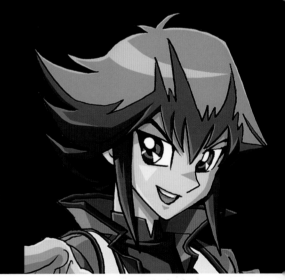

WORLDS OF YU-GI-OH!

Listed here are the various worlds of "Yu-Gi-Oh!". Though these settings transcend time and space, they all possess that quintessential spirit of the original series. The latter three protagonists all have in their names the same "Yu" of the original protagonist, Yugi Mutou, and through them we get to witness the gradual evolution of duels.

CONTRAPOSITION

For better or worse, fate has a tendency to bring opposing wills together. They clash, they rely on each other, and finally they part ways. This concept of "contraposition" - where these disparate spirits meet - could be called the cornerstone of "Yu-Gi-Oh!"'s world.

Contraposition ~

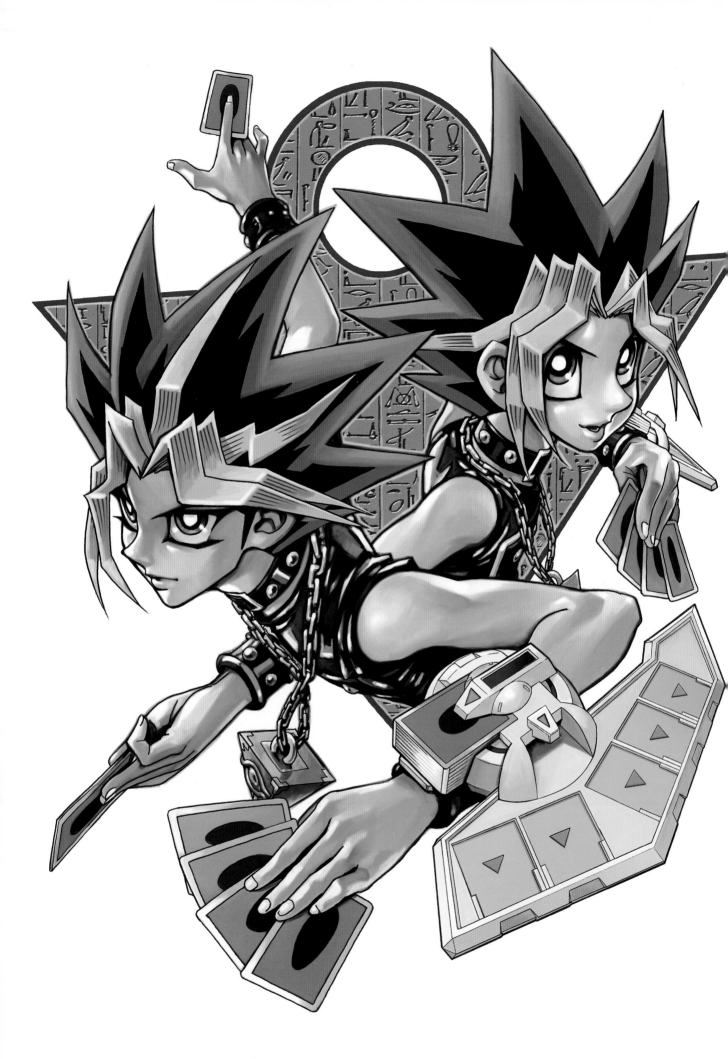

DECEMBER 16TH, 2011: Duel Art: Kazuki Takahashi Yu-Gi-Oh! Illustrations Cover Illustration

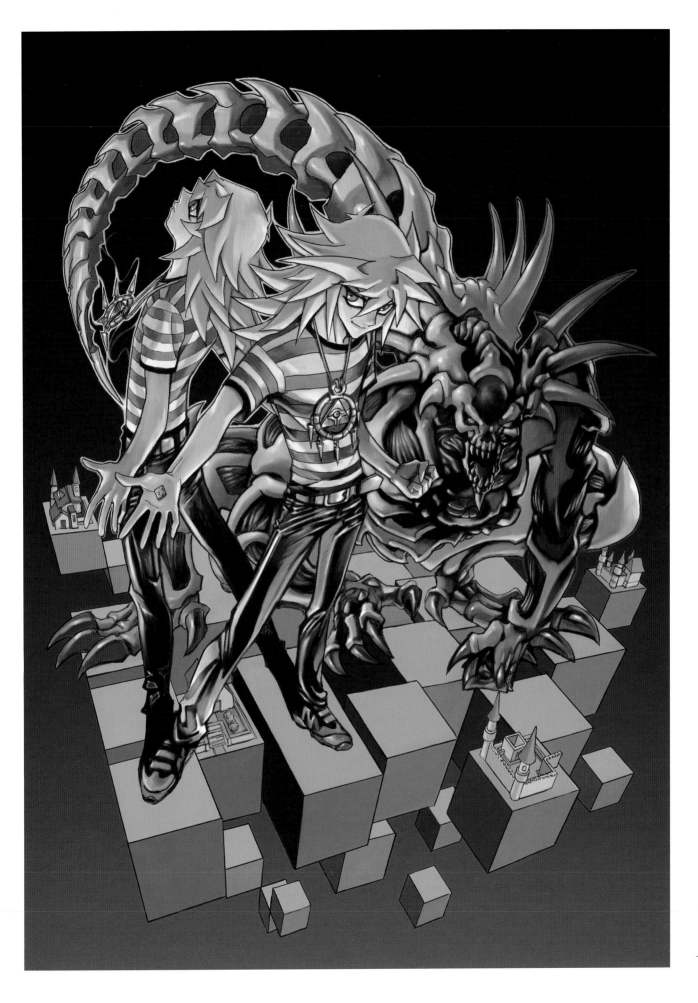

DECEMBER 16TH, 2011: Illustration for Duel Art: Kazuki Takahashi Yu-Gi-Oh! Illustrations

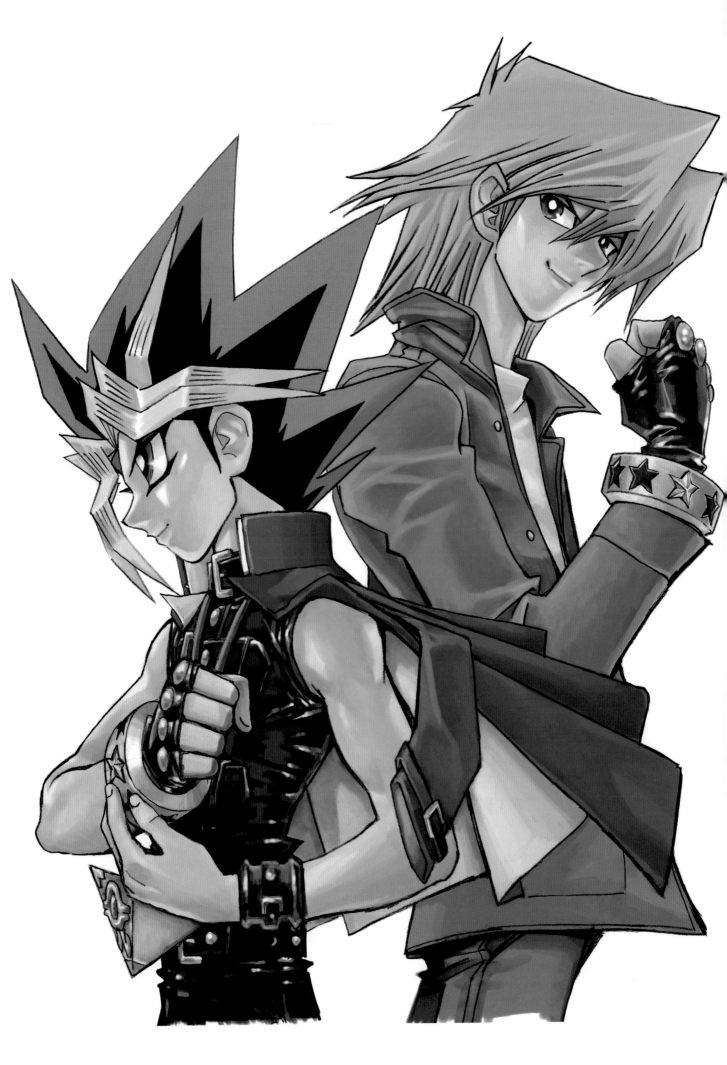

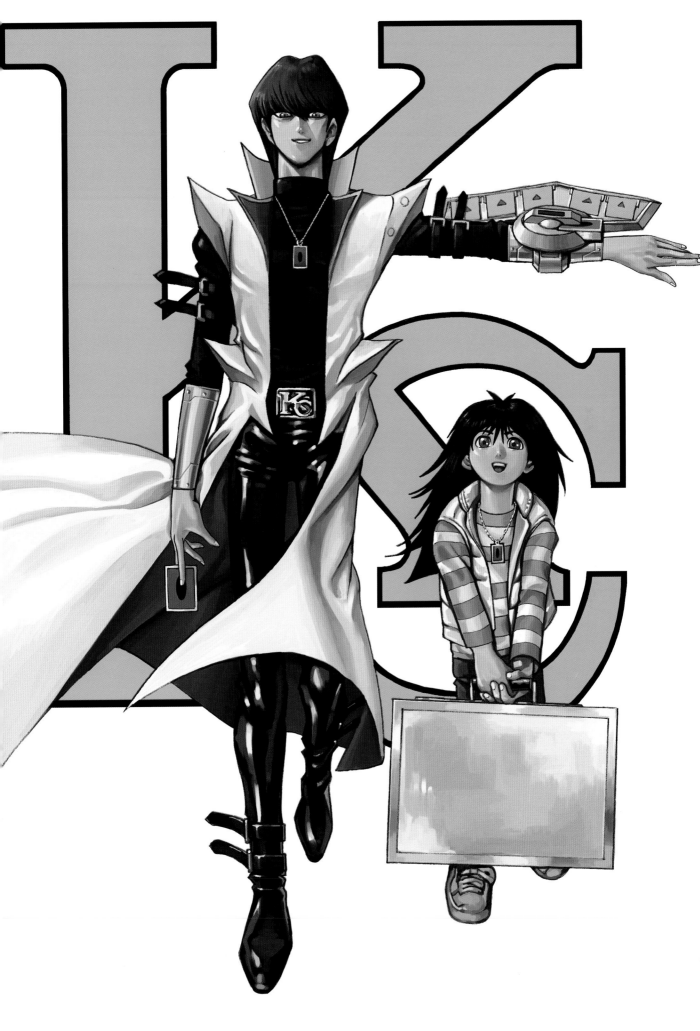

DECEMBER 16TH, 2011: Duel Art: Kazuki Takahashi Yu-Gi-Oh! Illustrations: Compiled Illustration

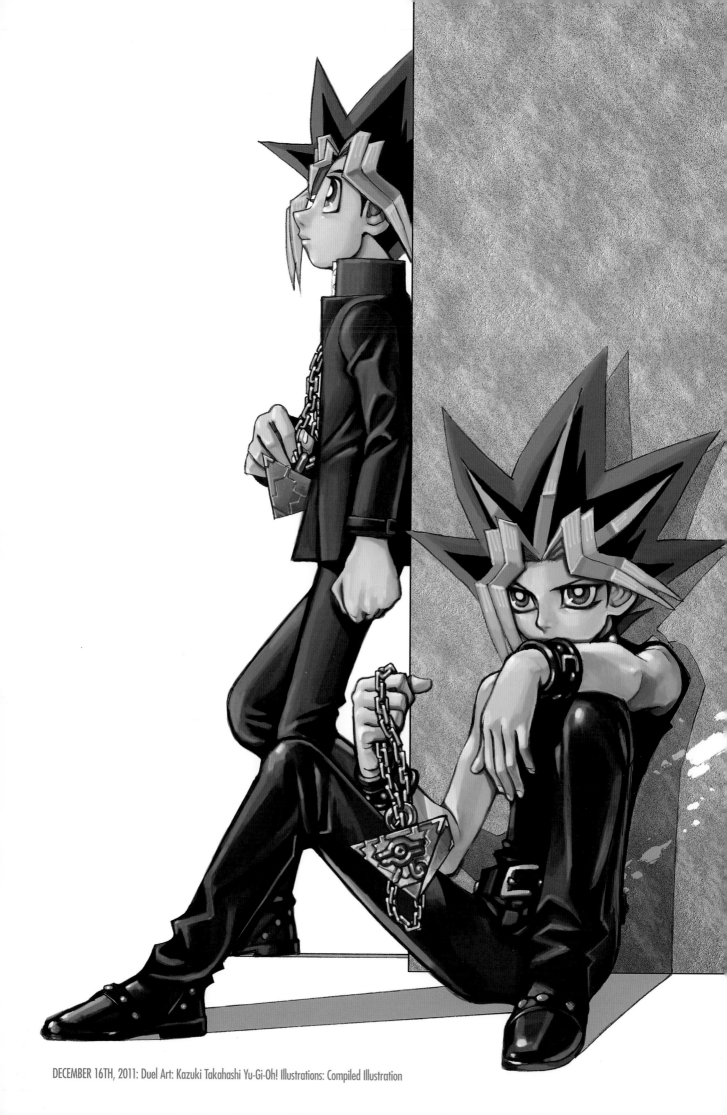

DECEMBER 16TH, 2011: Duel Art: Kazuki Takahashi Yu-Gi-Oh! Illustrations: Compiled Illustration

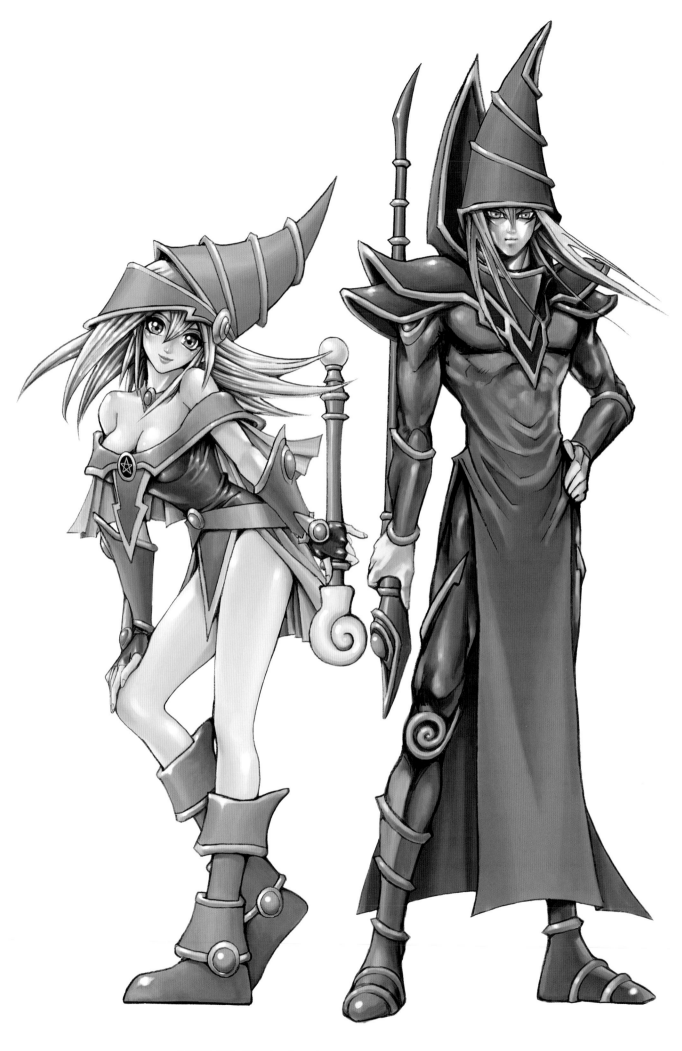

OCTOBER 23RD, 2007: Shueisha Bunko's (Comics) Yu-Gi-Oh! Volume 11 Cover Illustration

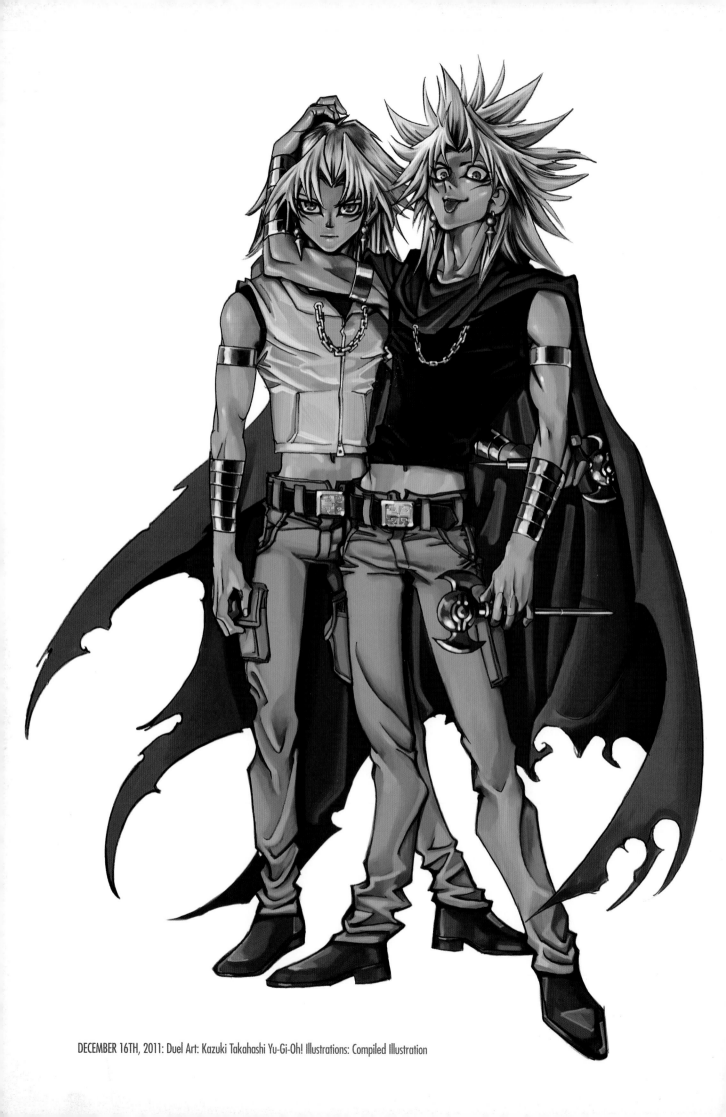

DECEMBER 16TH, 2011: Duel Art: Kazuki Takahashi Yu-Gi-Oh! Illustrations: Compiled Illustration

SOUL

With a proud sword in their right hand and a shield of spirit in their left, duelists fight to determine their fates. They support each other as friends and oppose each other as rivals, and the never-ending "duel" ties their very souls together.

Soul

— 1 —

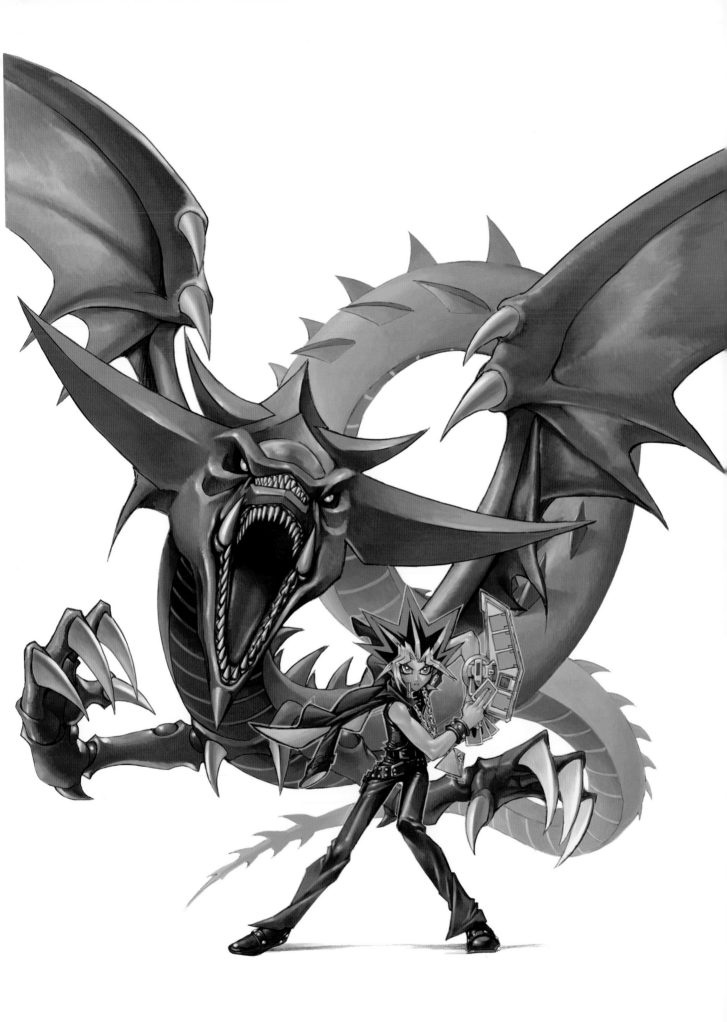

NOVEMBER 21ST, 2007: Shueisha Bunko's (Comics) Yu-Gi-Oh! Volume 14 Cover Illustration

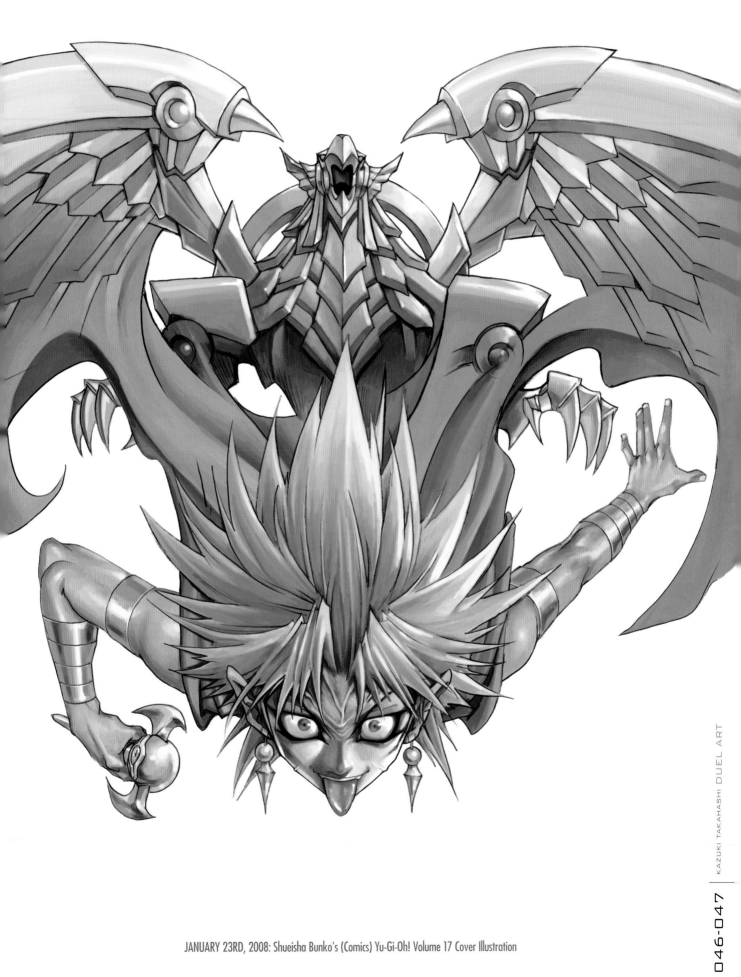

JANUARY 23RD, 2008: Shueisha Bunko's (Comics) Yu-Gi-Oh! Volume 17 Cover Illustration

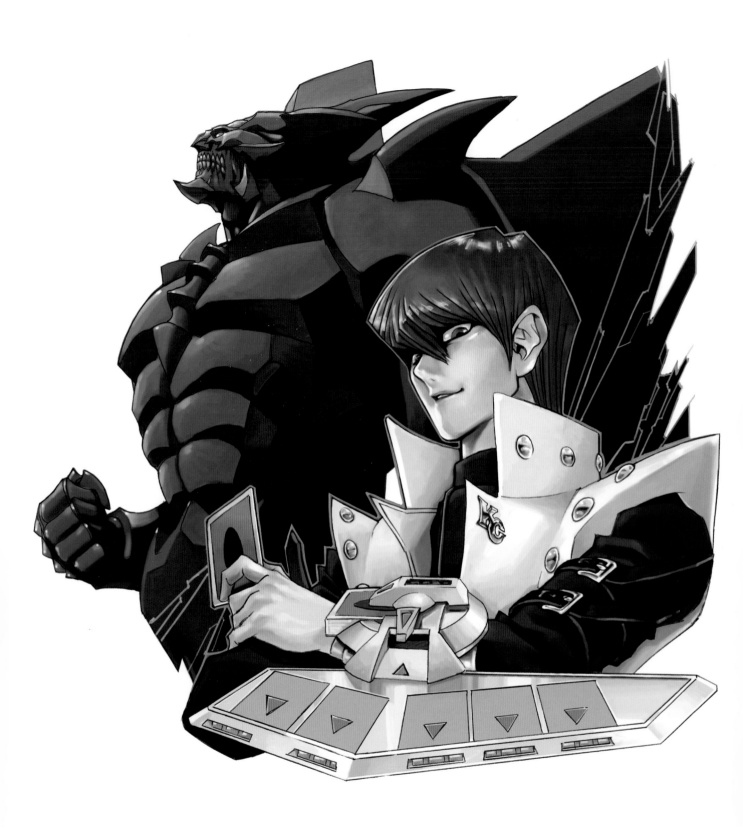

OCTOBER 23RD, 2007: Shueisha Bunko's (Comics) Yu-Gi-Oh! Volume 12 Cover Illustration

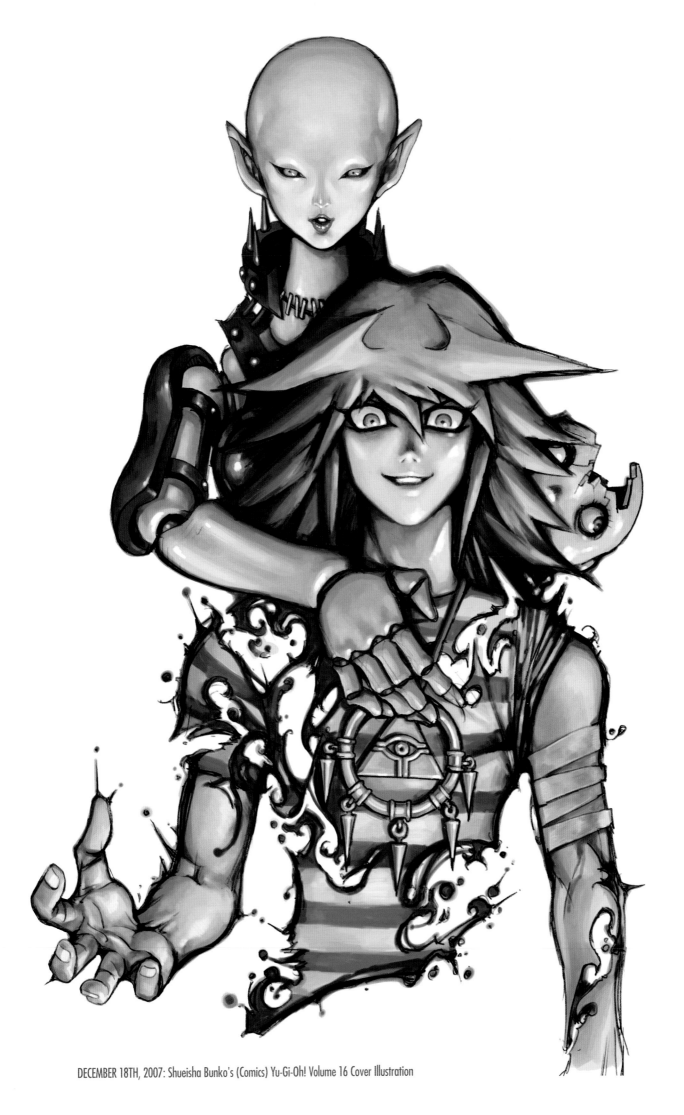

DECEMBER 18TH, 2007: Shueisha Bunko's (Comics) Yu-Gi-Oh! Volume 16 Cover Illustration

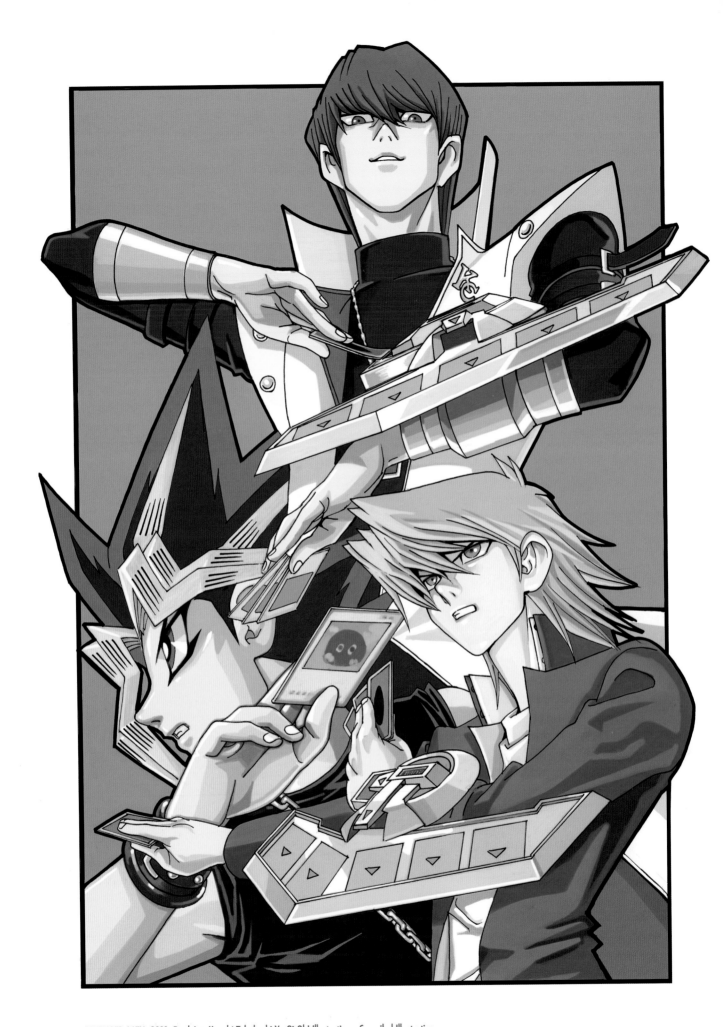

DECEMBER 16TH, 2011: Duel Art: Kazuki Takahashi Yu-Gi-Oh! Illustrations: Compiled Illustration

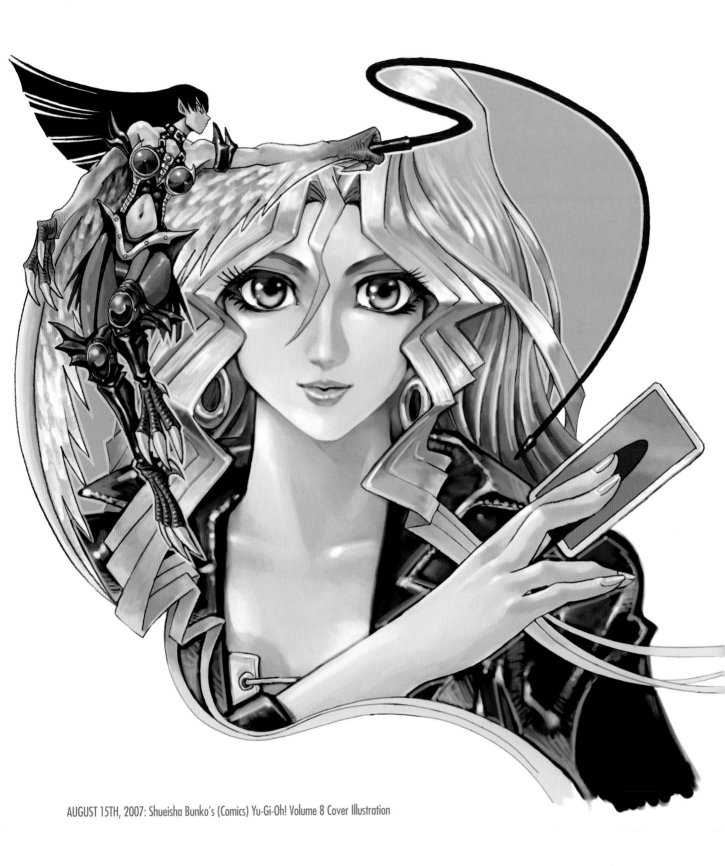

AUGUST 15TH, 2007: Shueisha Bunko's (Comics) Yu-Gi-Oh! Volume 8 Cover Illustration

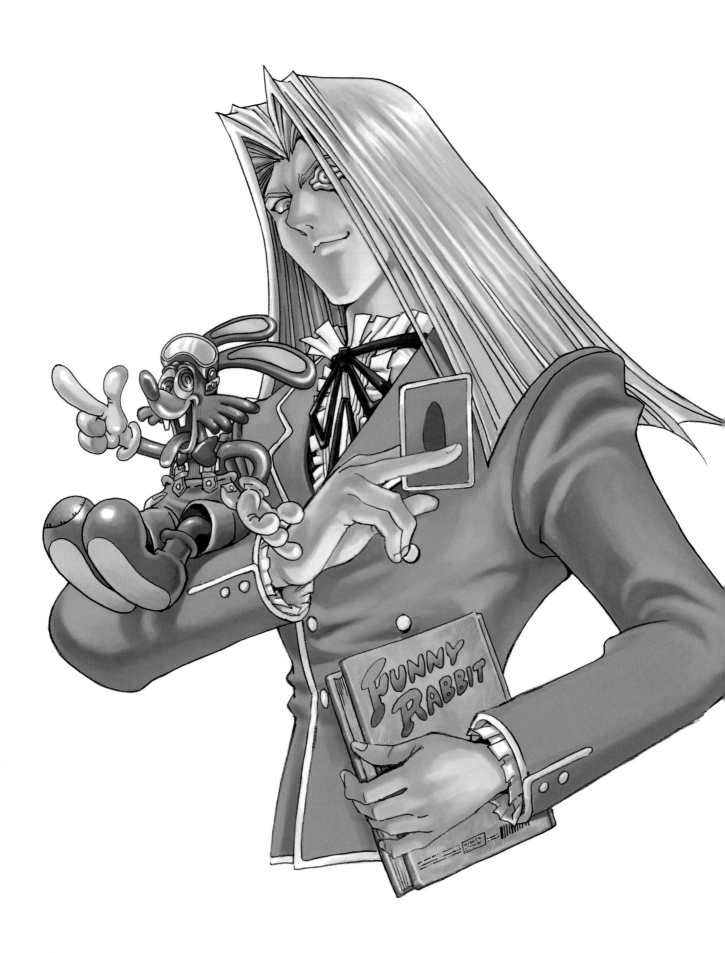

JULY 23RD, 2007: Shueisha Bunko's (Comics) Yu-Gi-Oh! Volume 6 Cover Illustration

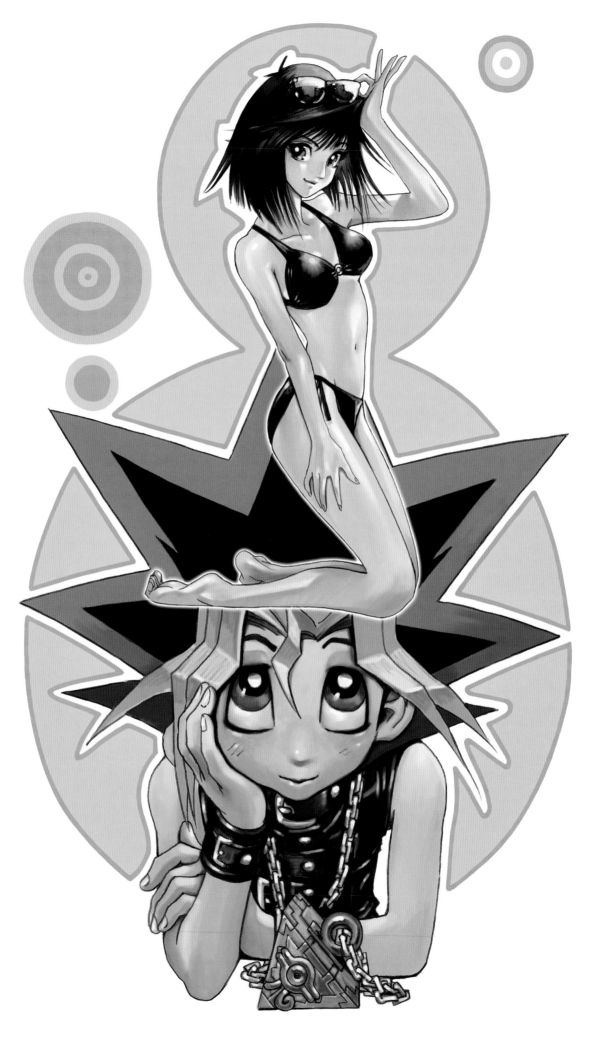

DECEMBER 16TH, 2011: Illustration for Duel Art: Kazuki Takahashi Yu-Gi-Oh! Illustrations

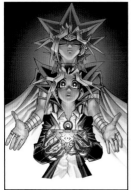

▲The completion of the Millennium Puzzle - unearthed in Egypt - heralds the beginning of endless adventure...

▶ Dark Bakura seeks the Millennium Puzzle for himself and seals the spirits of Yugi and friends into "game pieces".

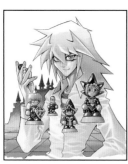

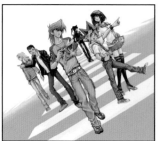

▲The friends wander the city in pursuit of a new game, but a formidable foe lurks in the shadows...

The priests and the pharaoh wield incredible power thanks to their Millennium items.

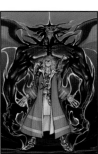

▲The Thief King ravages the pharaoh's tomb in search of the ultimate treasures!

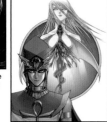

▲Seto, who seeks strength, and Kisara, who harbors a godlike power.

▼Retrieving the pharaoh's true name brings about a split millennium in the making.

▲When up against the unimaginably powerful Zorc, the bonds of friends bring about a miracle.

THE STORY OF YU-GI-OH!

Yu-Gi-Oh!'s story follows the two Yugis - brought together by the Millennium Puzzle - as they fight fierce battles against countless foes and use the power of their bond to recover the ancient Yugi's true name.

School Arc

When Yugi Mutou completes the Millennium Puzzle, "another" Yugi is born within him, and the two must face a number of villains in the incredible "Shadow Games".

Death-T Arc

Humiliated after his loss in the "Shadow Games", Seto Kaiba constructs "Death-T" - a deadly attraction meant to help him exact revenge on Yugi.

RPG Arc

Controlled by the darkness within his Millennium item, Ryo Bakura seals Yugi and friends' souls into "Adventure Board Game: Monster World", where dark ruler Zorc reigns.

Duelist Kingdom Arc

Yugi's grandfather Solomon has his soul stolen away by the president of Industrial Illusions, Pegasus. The only way to save him is to challenge Pegasus and become the champion of Duelist Kingdom.

DDM Arc

Duke Devlin challenges Yugi to a game of DDM (Dungeon Dice Monsters) in order to take revenge on his father's behalf. Yugi has to win back the Millennium Puzzle and his "other self" using nothing but his own strength.

Battle City Arc

Descendant of the Tomb Keepers Ishizu Ishtar uses Kaiba's tournament as a chance to gather the "god cards". What unfolds is an epic series of deadly battles.

Millennium World Arc

The final "game" of the series begins when Yugi gathers all of the Millennium items and god cards, leading to a trip through time to recover the pharaoh's lost memories and name.

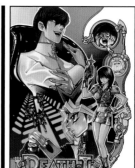

◀The deadly attraction features five life-threatening games.

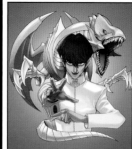

◀Kaiba is overwhelmingly powerful thanks to his legendary card. The almighty Blue Eyes White Dragon bears its fangs!!

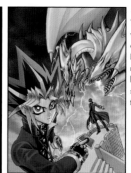

◀Yugi has finally won the right to challenge Pegasus, but now his longtime rival stands in the way.

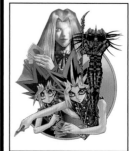

◀Pegasus can see all with his Millennium Eye, so Yugi's only hope is to use his split personality as a weapon...

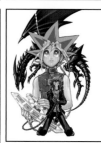

◀One of Marik's traps shatters the bond between these two close friends, and they're forced to challenge each other.

▼Many millennia of tragic events have shaped these siblings' destinies. Can Ishizu save her brother from darkness?

▼With their pride and the god cards on the line, these legendary duelists clash...!!

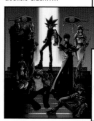

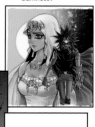

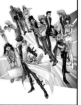

▶ After a fierce fight, the victorious duelists are invited to yet another challenge.

MEMORY

Guidance from the Millennium Puzzle brings the
two Yugis together. No matter what challenges
stand in their way, their strong wills allow them to
press on in their quest to discover the pharaoh's
lost name. This is the story of "Yu-Gi-Oh!",
presented here in a number of representative
illustrations. Forged through countless meetings
and partings, these memories will never die.

-Memory-

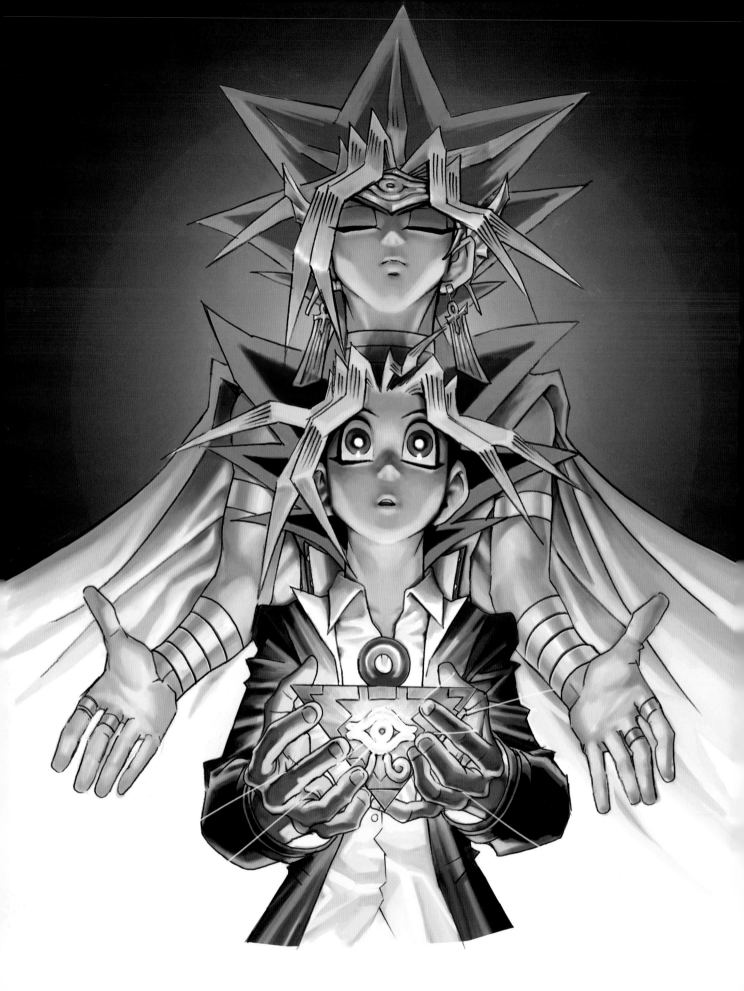

APRIL 23RD, 2007: Shueisha Bunko's (Comics) Yu-Gi-Oh! Volume 1 Cover Illustration

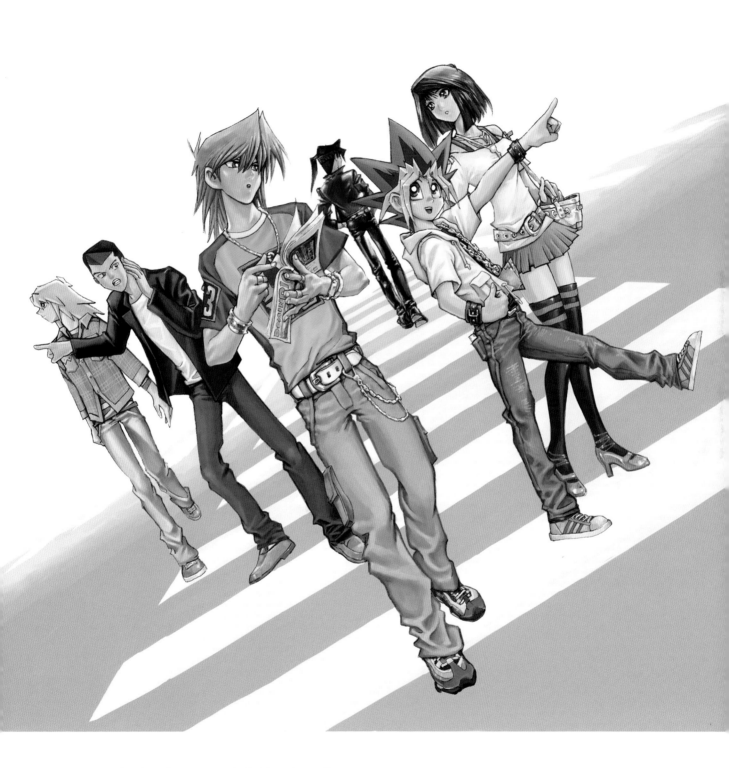

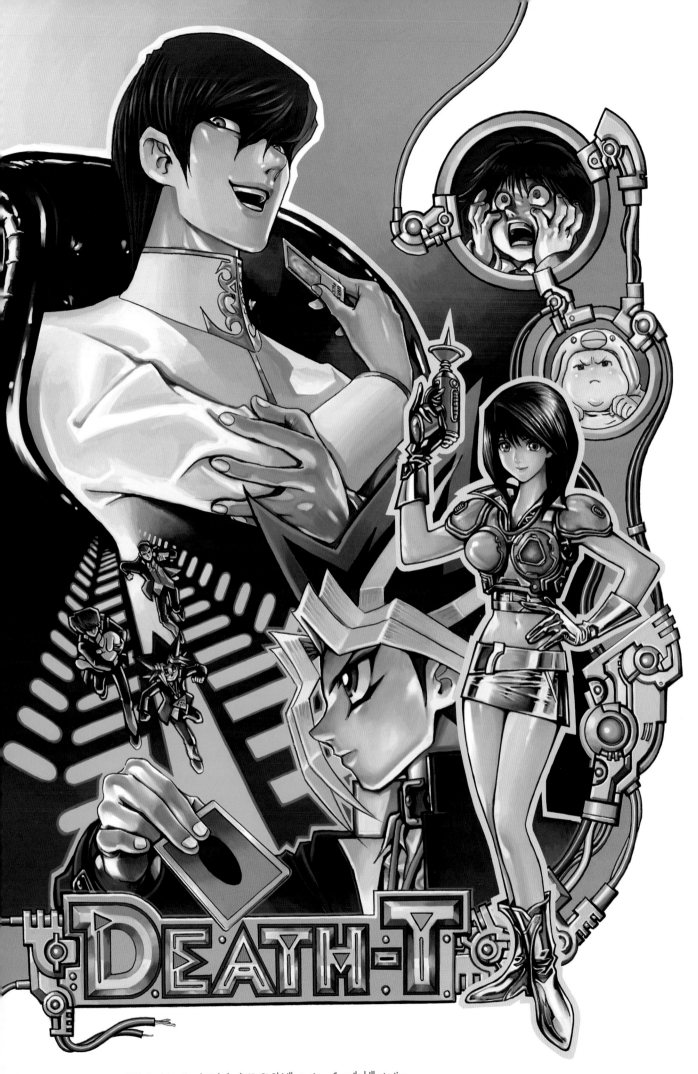

DECEMBER 16TH, 2011: Duel Art: Kazuki Takahashi Yu-Gi-Oh! Illustrations: Compiled Illustration

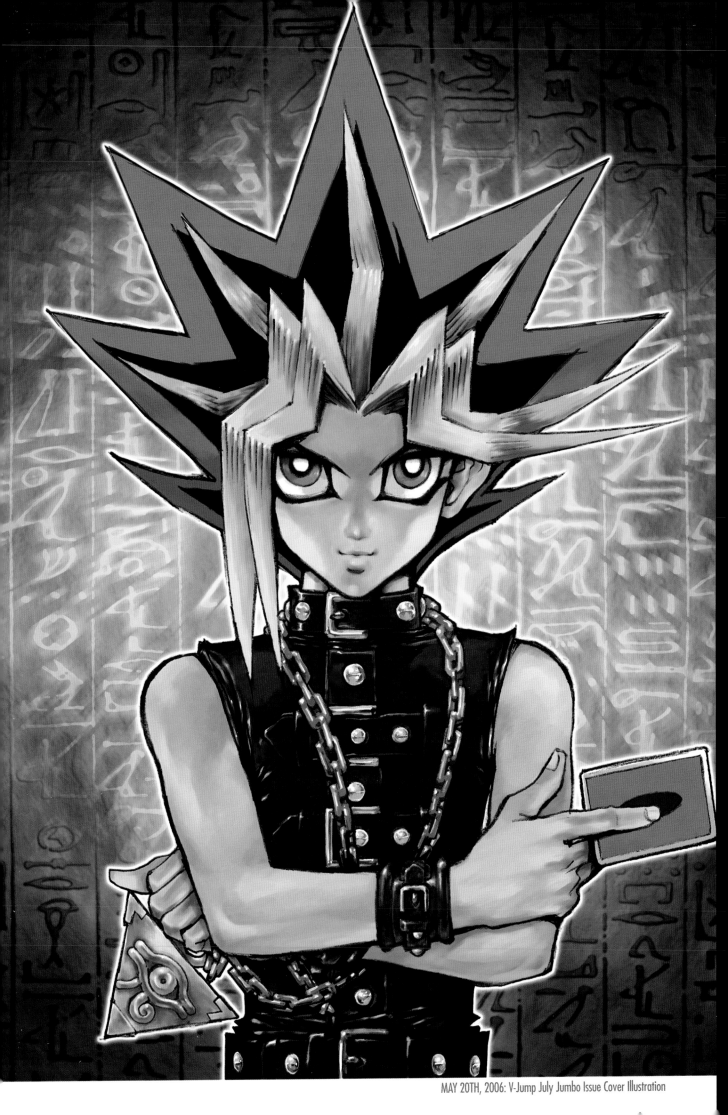

MAY 20TH, 2006: V-Jump July Jumbo Issue Cover Illustration

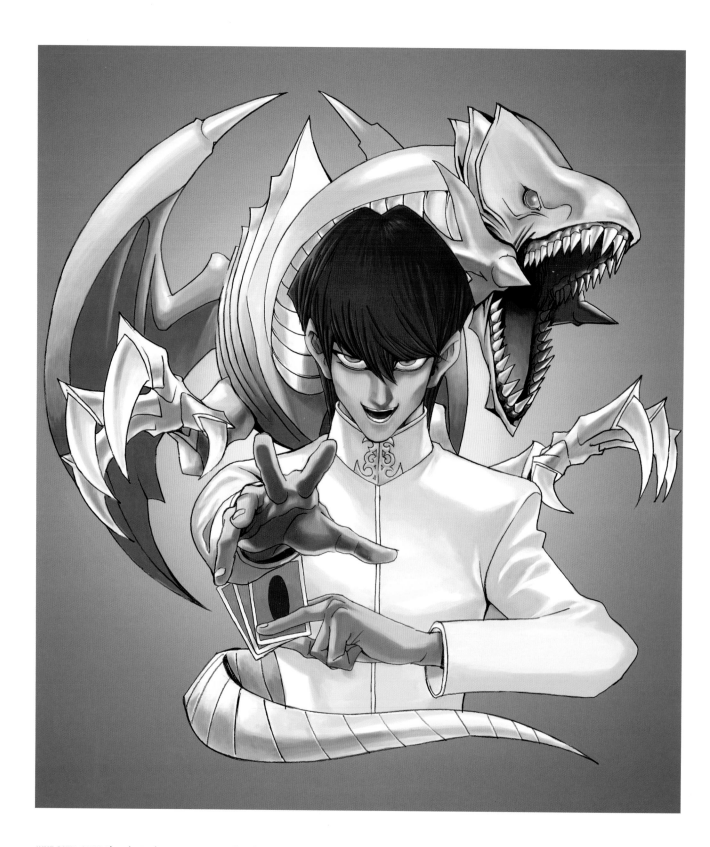

JUNE 20TH, 2007: Shueisha Bunko's (Comics) Yu-Gi-Oh! Volume 3 Cover Illustration

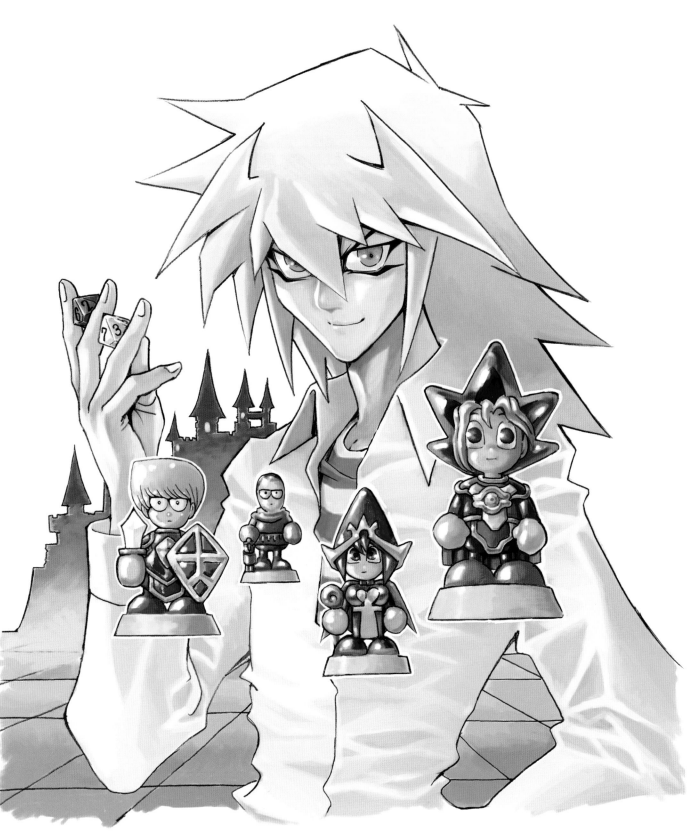

JUNE 20TH, 2007: Shueisha Bunko's (Comics) Yu-Gi-Oh! Volume 4 Cover Illustration

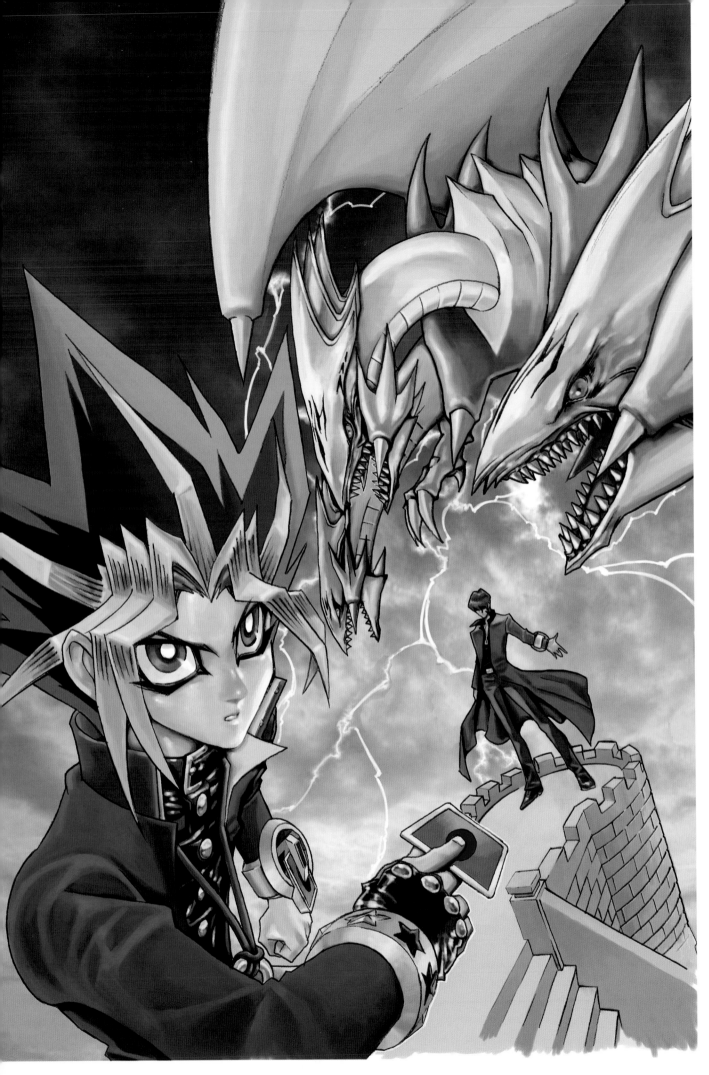

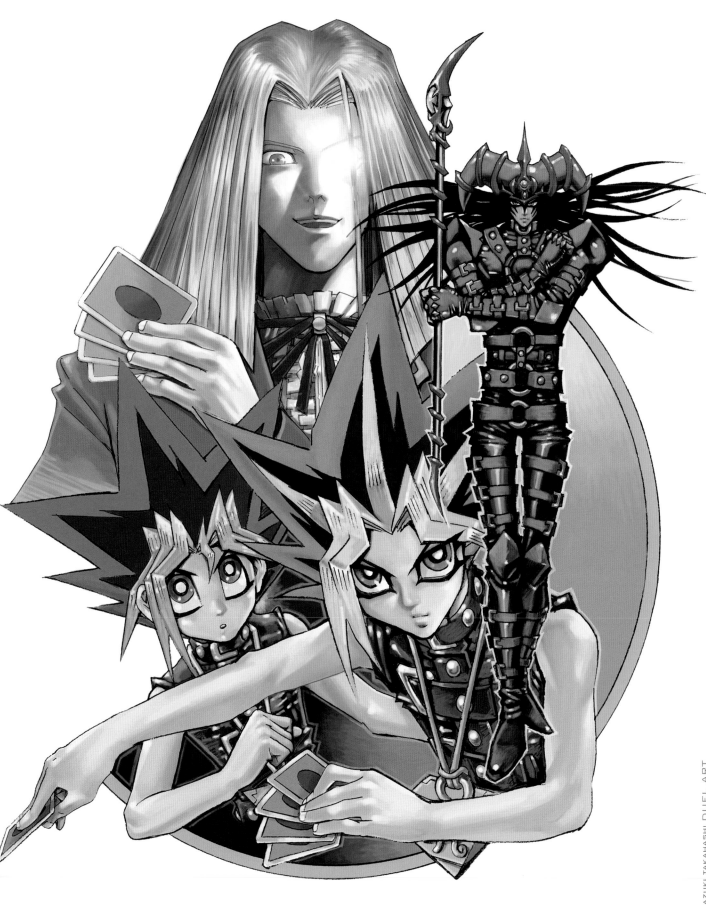

SEPTEMBER 19TH, 2007: Shueisha Bunko's (Comics) Yu-Gi-Oh! Volume 9 Cover Illustration

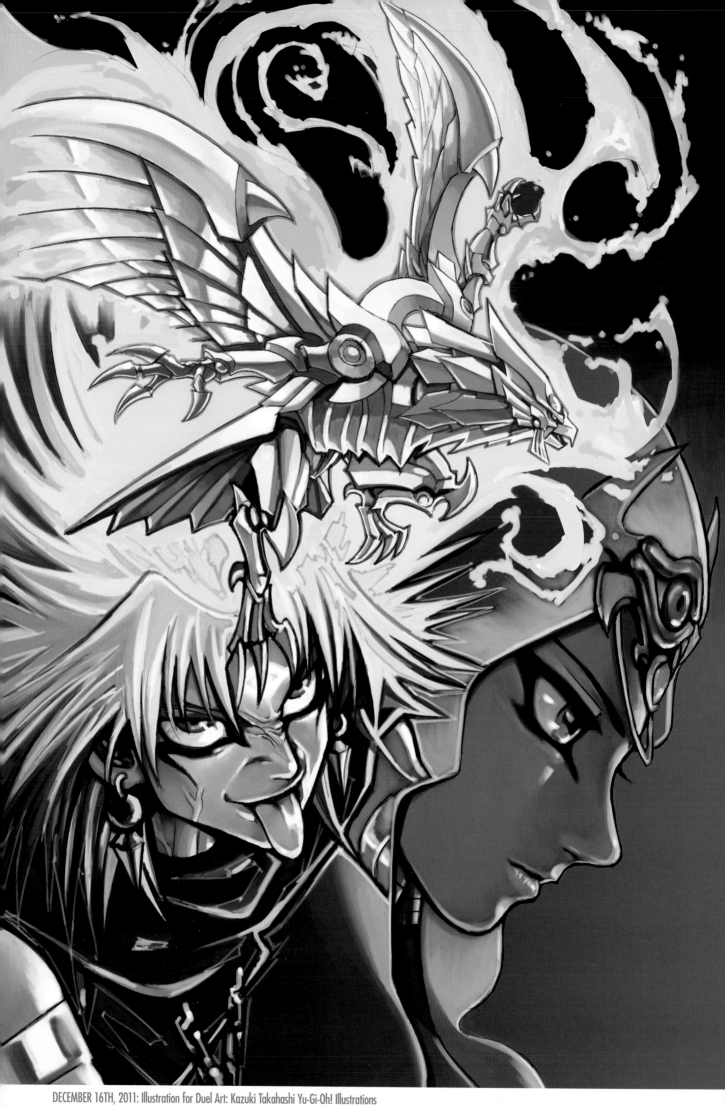

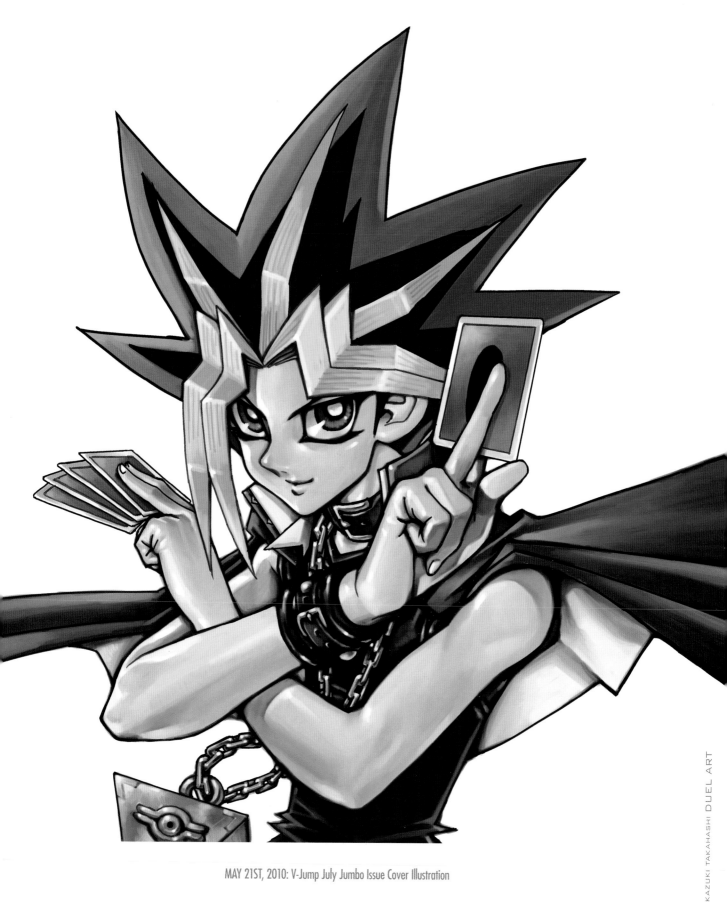

MAY 21ST, 2010: V-Jump July Jumbo Issue Cover Illustration

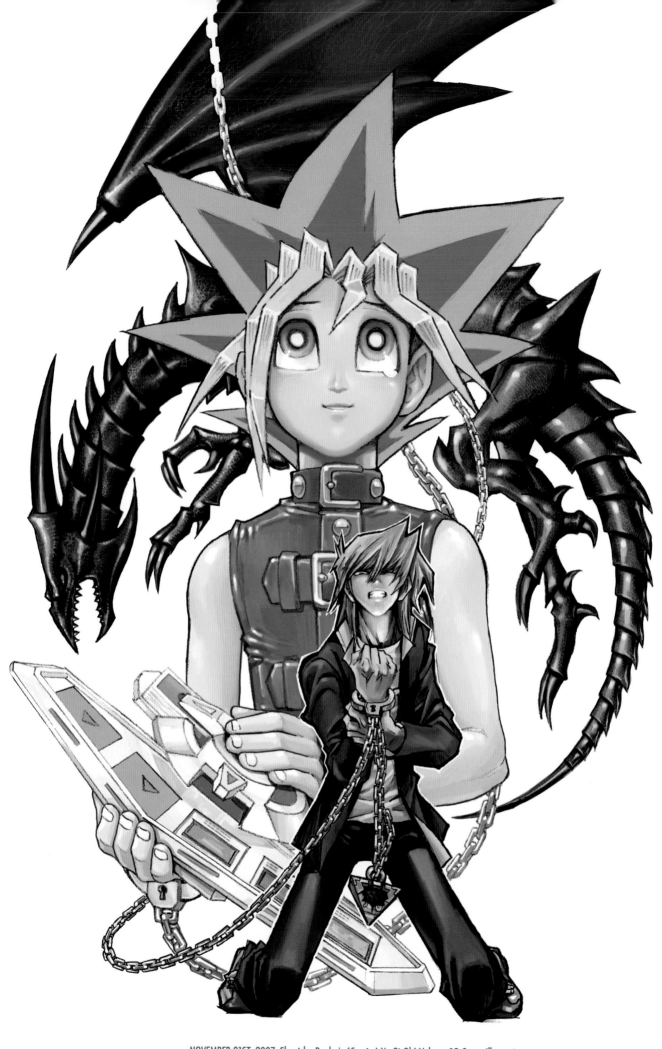

NOVEMBER 21ST, 2007: Shueisha Bunko's (Comics) Yu-Gi-Oh! Volume 13 Cover Illustration

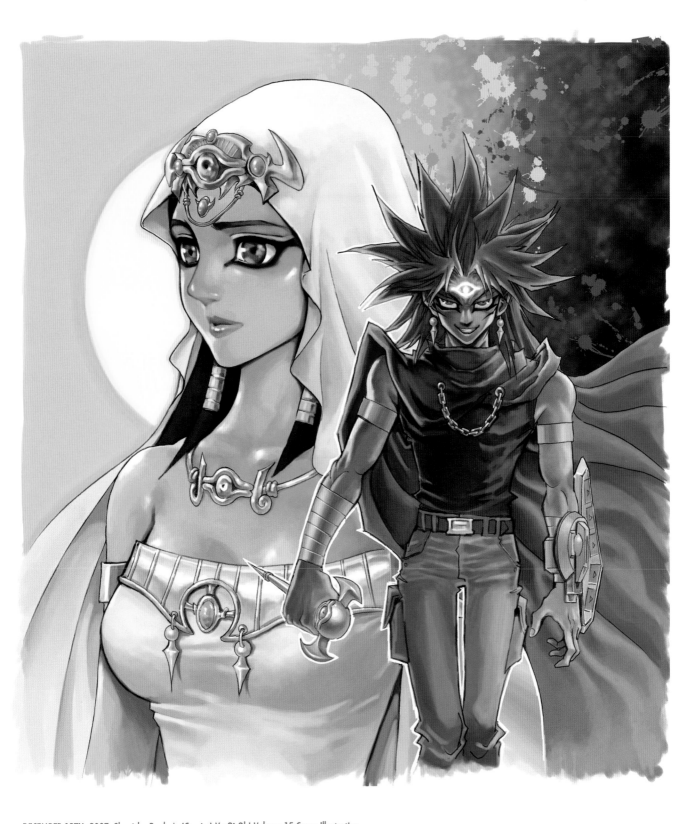

DECEMBER 18TH, 2007: Shueisha Bunko's (Comics) Yu-Gi-Oh! Volume 15 Cover Illustration

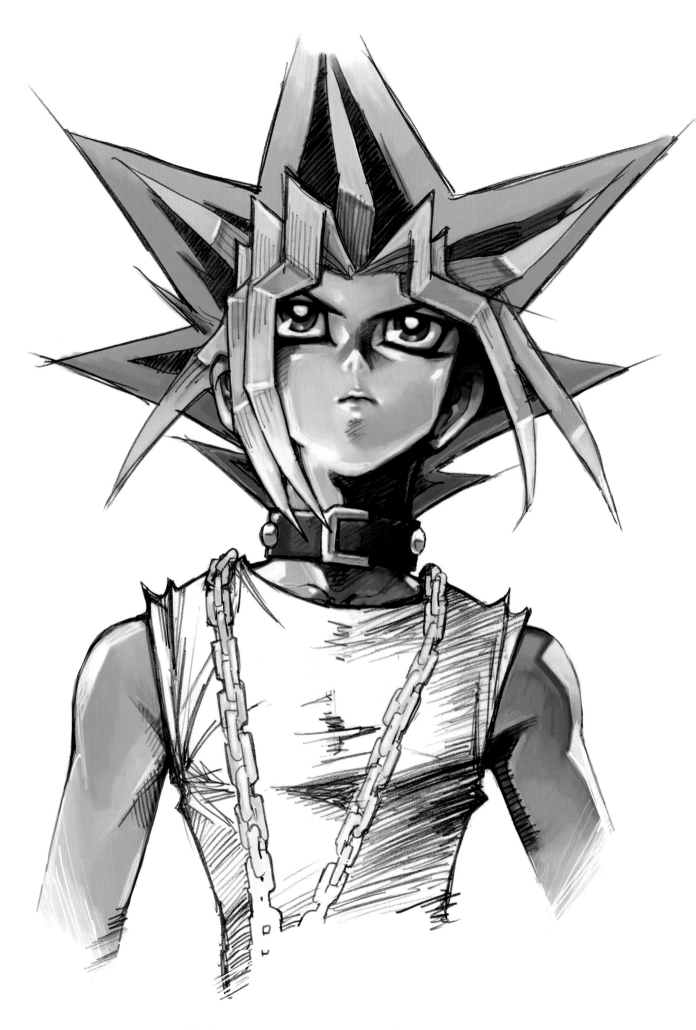

DECEMBER 16TH, 2011: Duel Art: Kazuki Takahashi Yu-Gi-Oh! Illustrations: Compiled Illustration

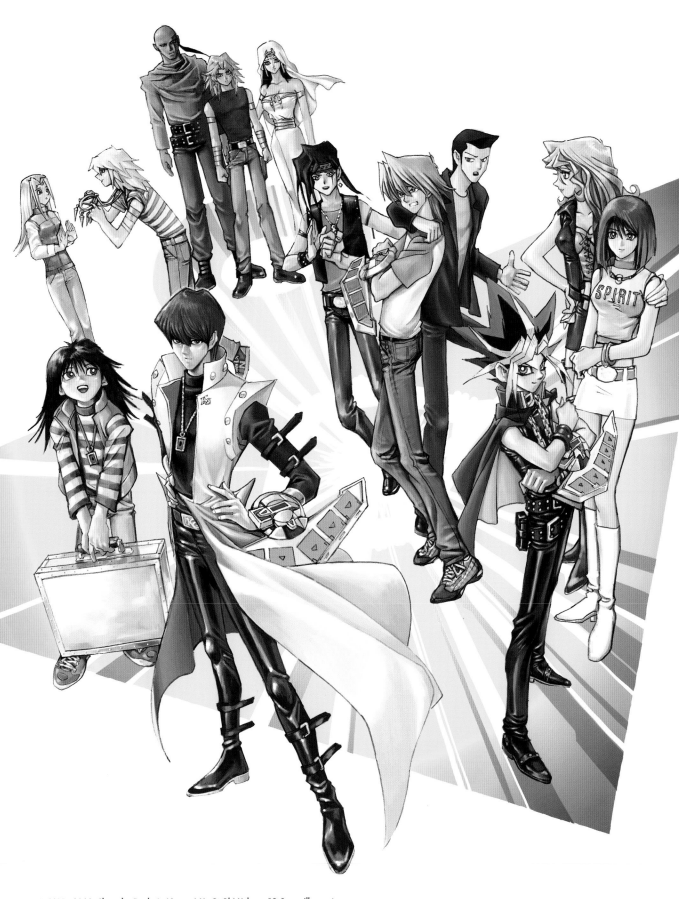

JANUARY 23RD, 2008: Shueisha Bunko's (Comics) Yu-Gi-Oh! Volume 18 Cover Illustration

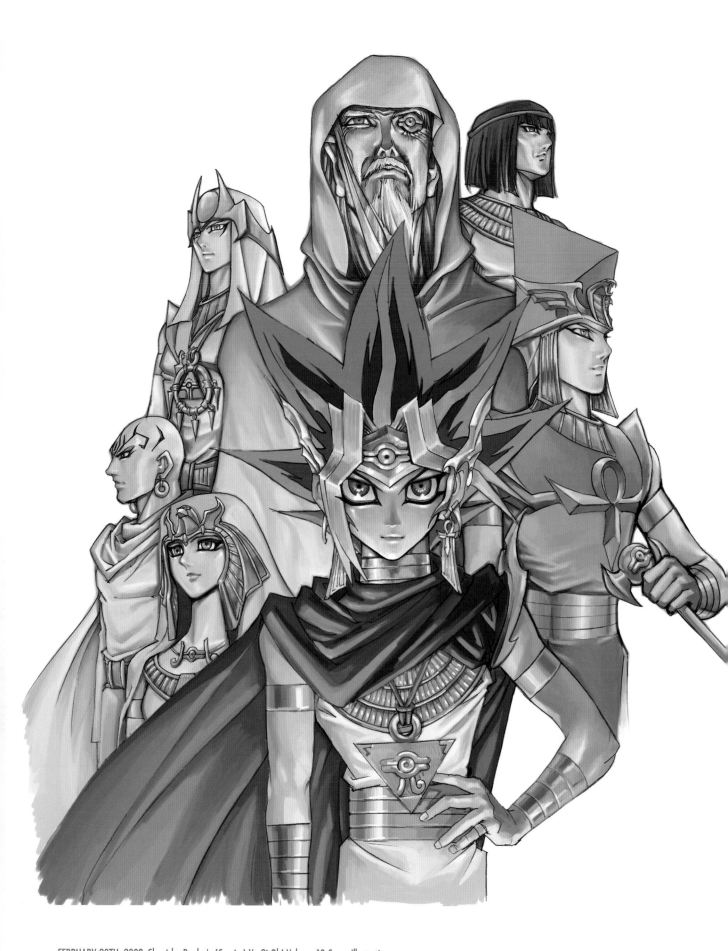

FEBRUARY 20TH, 2008: Shueisha Bunko's (Comics) Yu-Gi-Oh! Volume 19 Cover Illustration

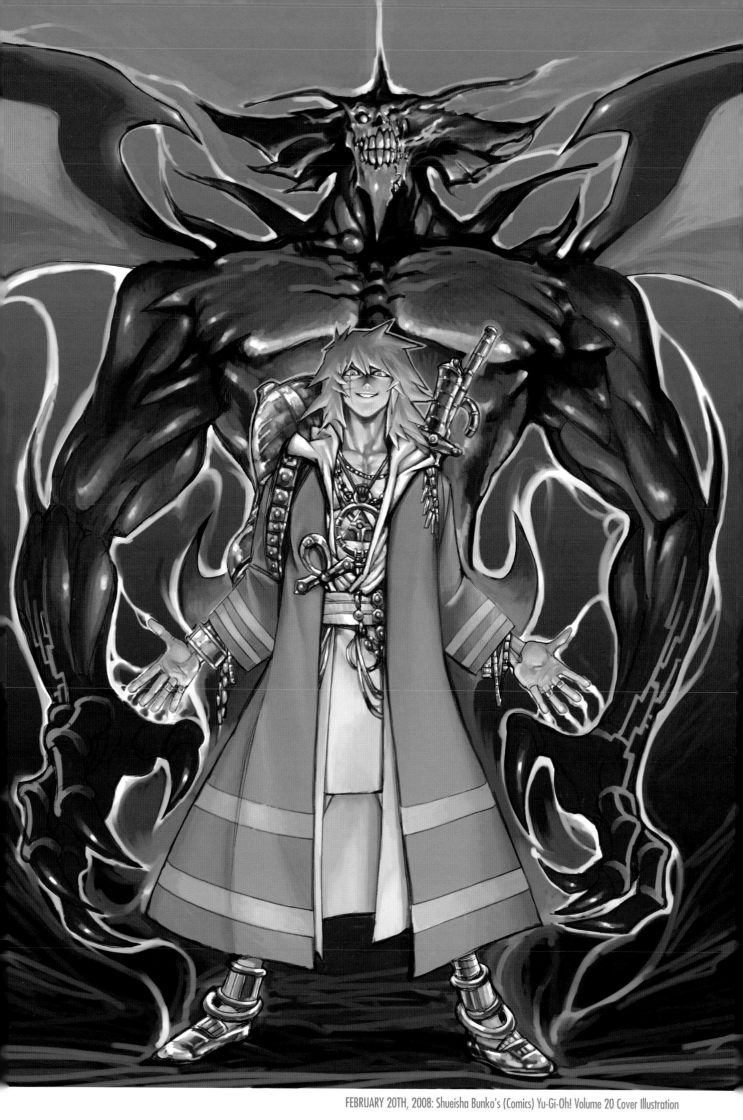

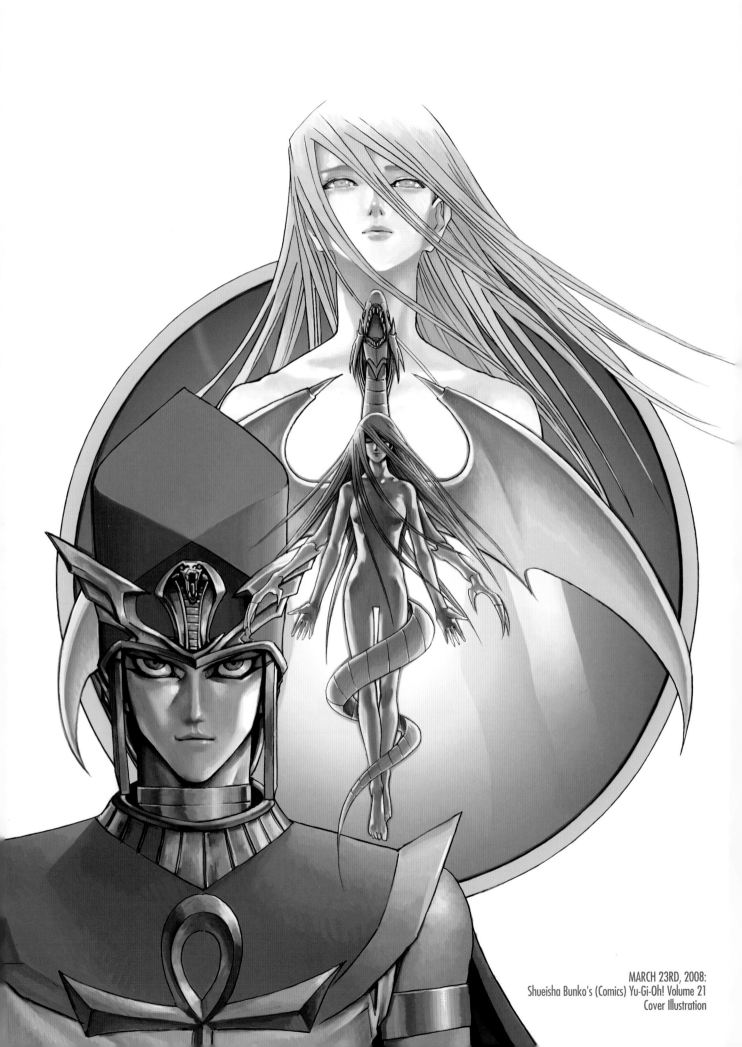

MARCH 23RD, 2008:
Shueisha Bunko's (Comics) Yu-Gi-Oh! Volume 21
Cover Illustration

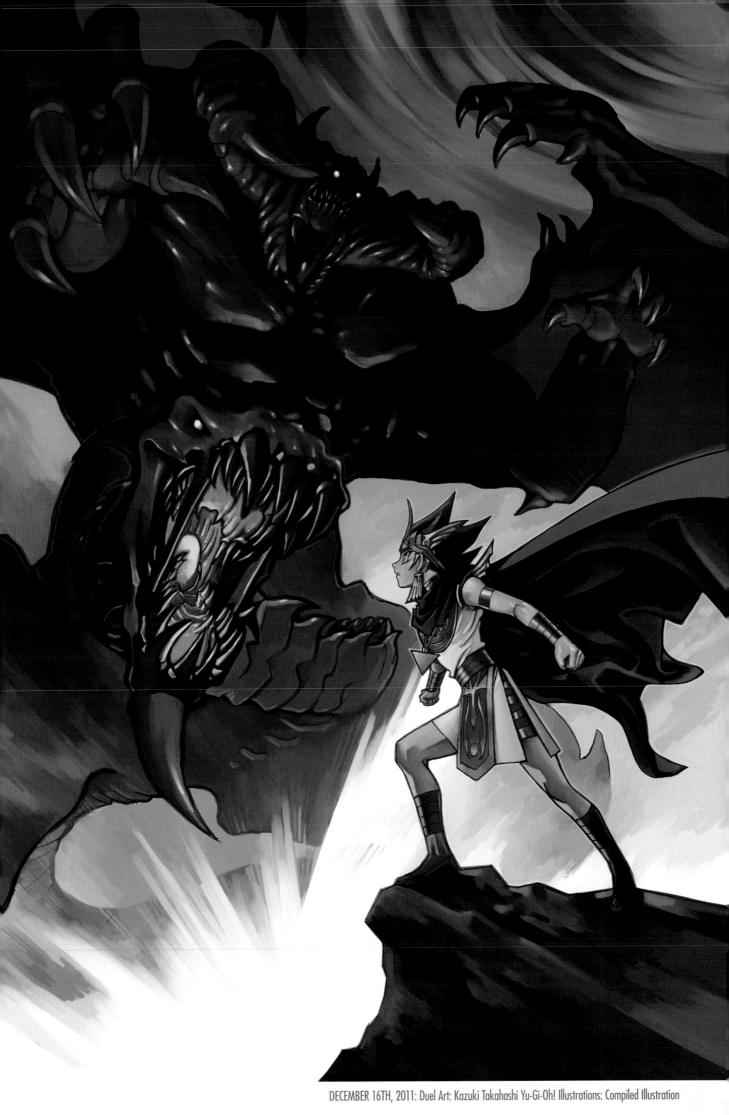

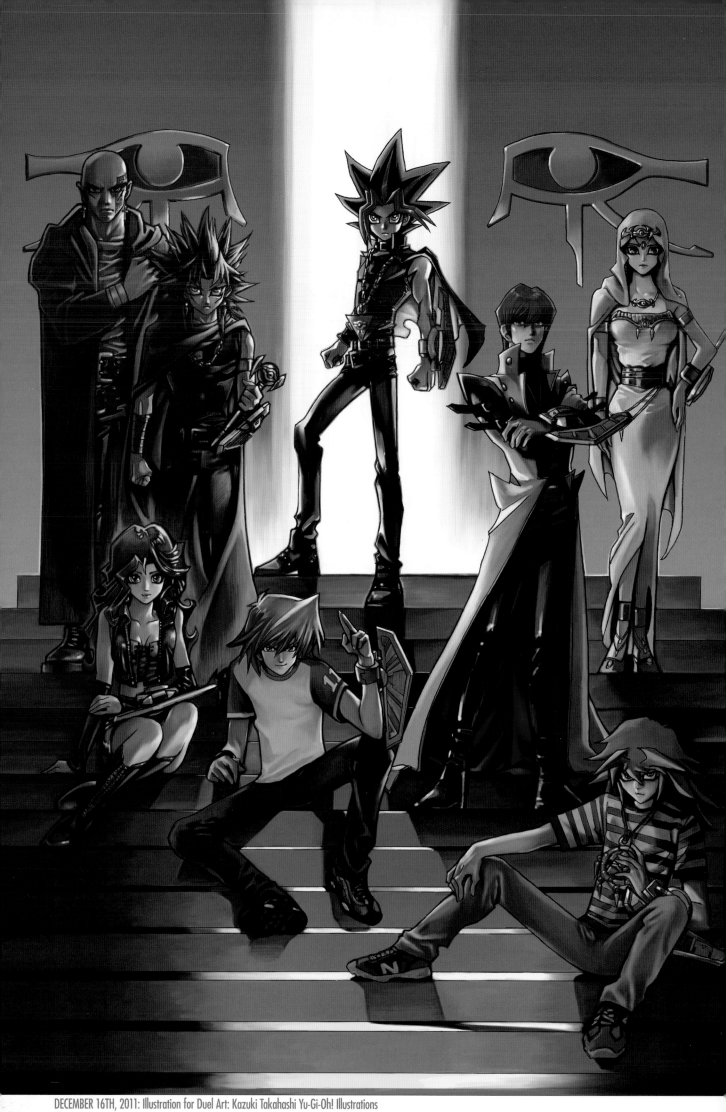

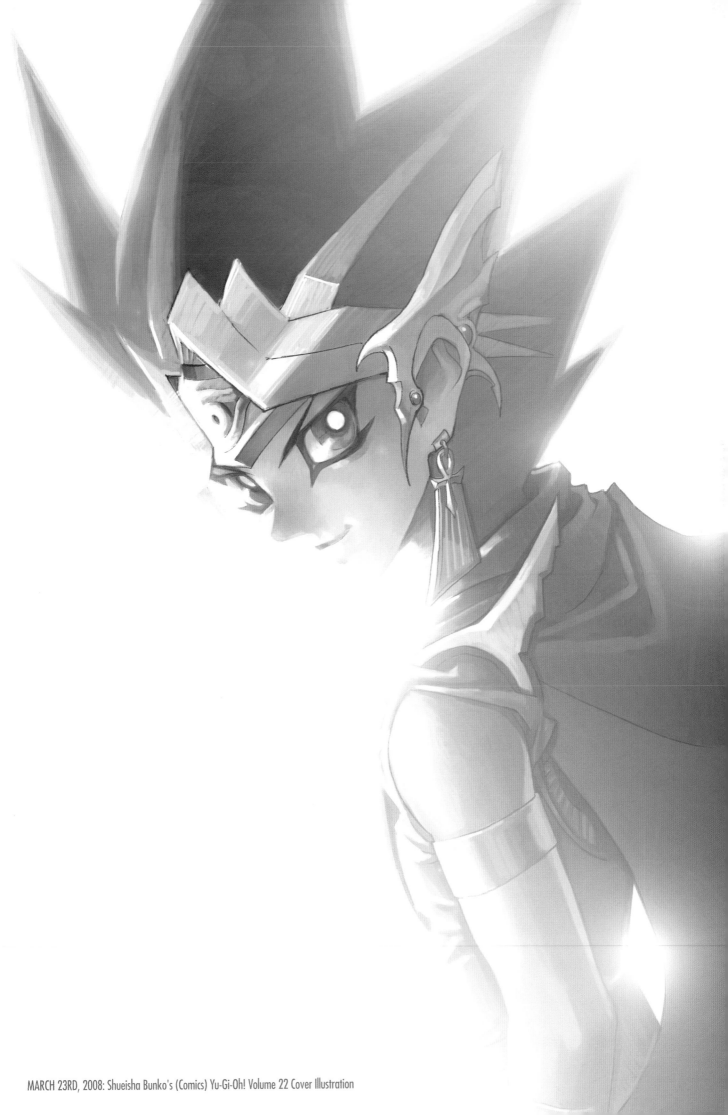

MARCH 23RD, 2008: Shueisha Bunko's (Comics) Yu-Gi-Oh! Volume 22 Cover Illustration

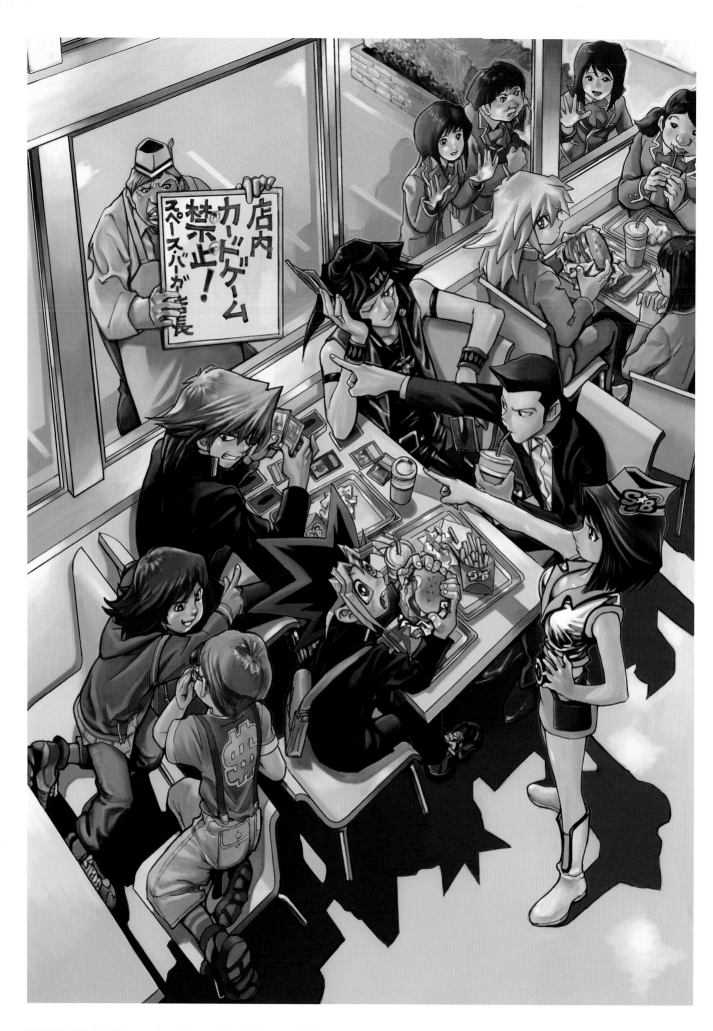

DECEMBER 16TH, 2011: Illustration for Duel Art: Kazuki Takahashi Yu-Gi-Oh! Illustrations
Sign translation: "No card games allowed in the store! - Manager of Space Burger"

MODEL

Modifying art to get just the perfect composition involves many steps and results in a large number of sketches. We hope you enjoy these rough sketches, or "model" illustrations.

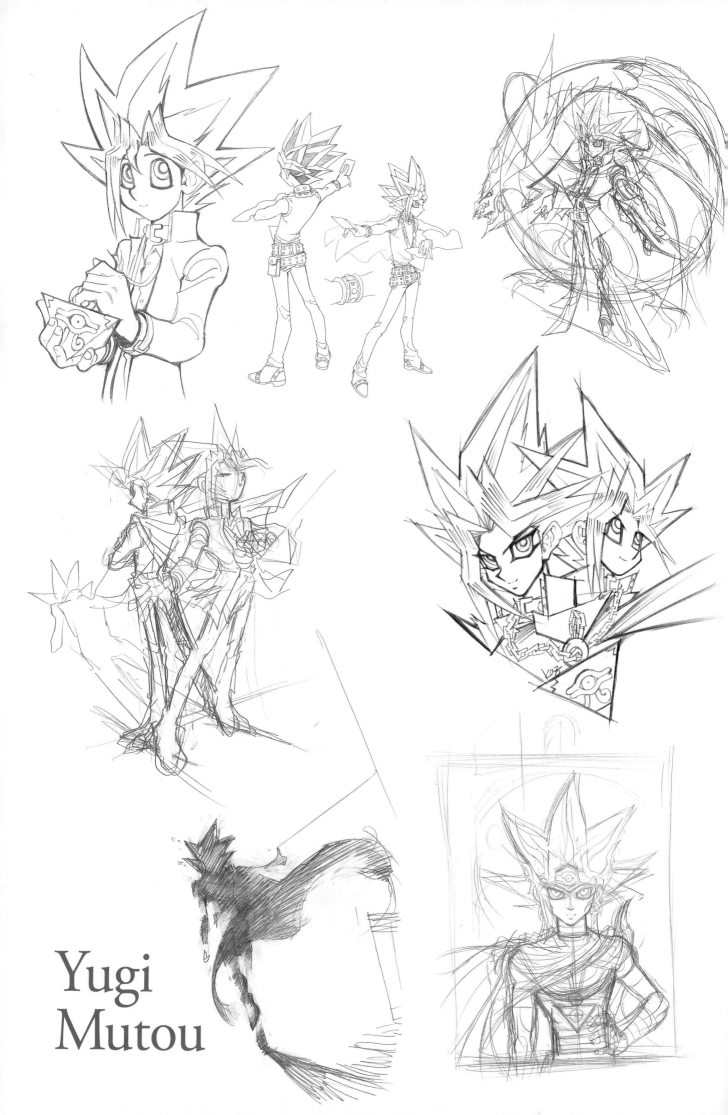

Yugi
Mutou

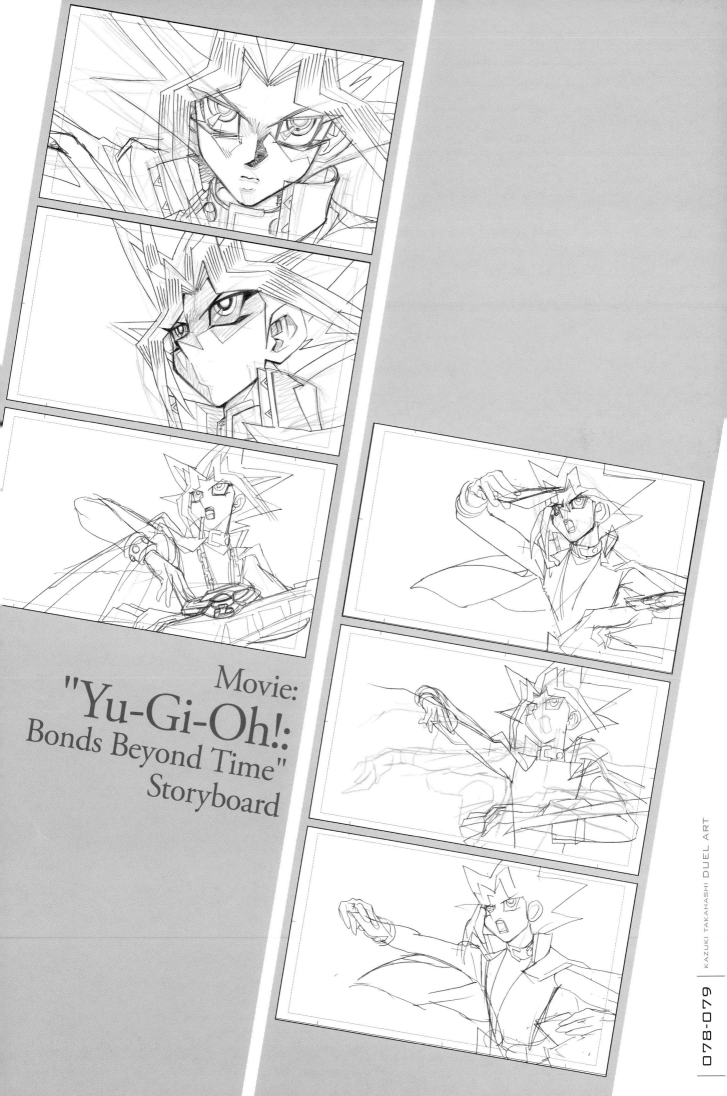

Movie: "Yu-Gi-Oh!: Bonds Beyond Time" Storyboard

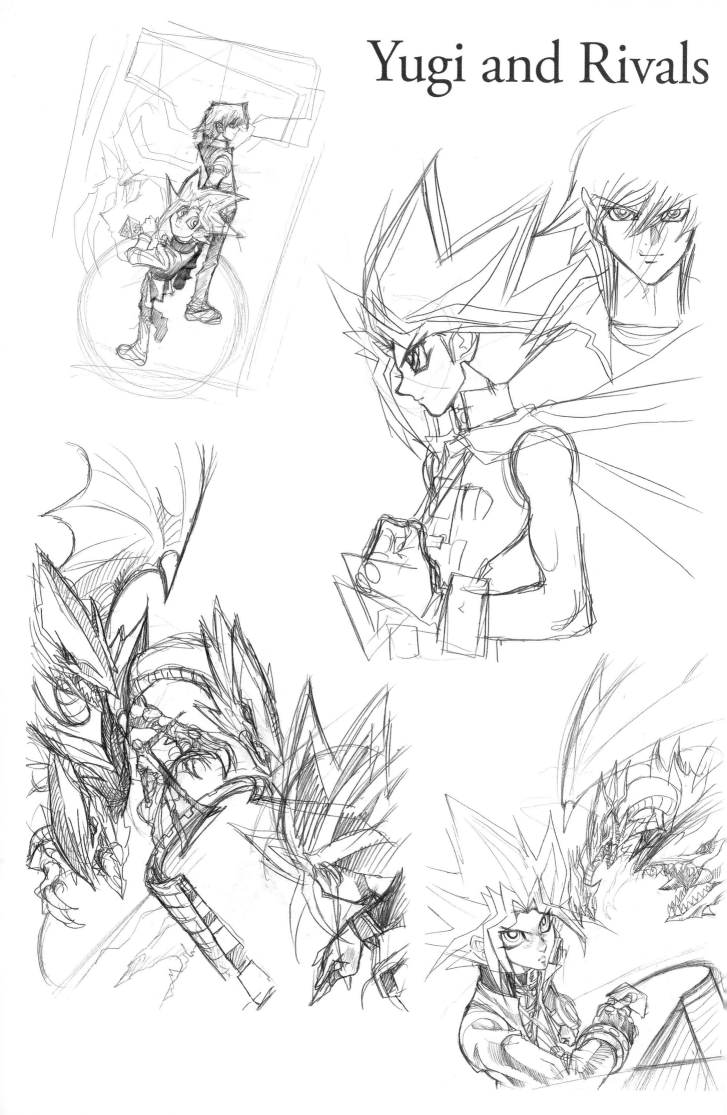

Yugi and Rivals

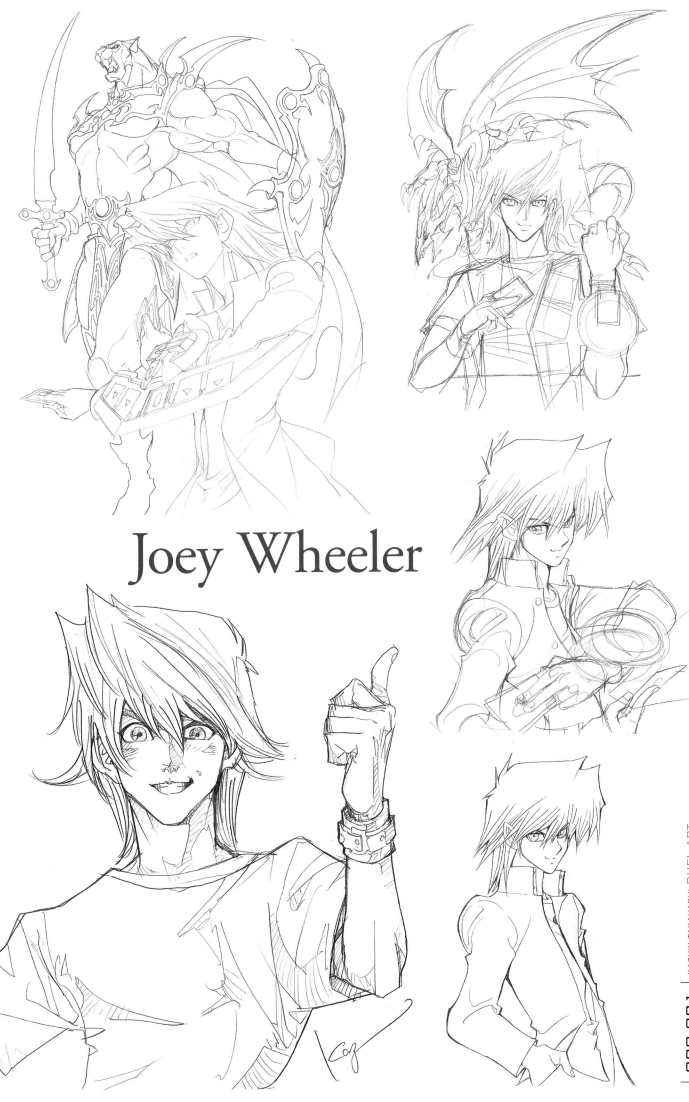

Joey Wheeler

KAZUKI TAKAHASHI DUEL ART

Seto
Kaiba

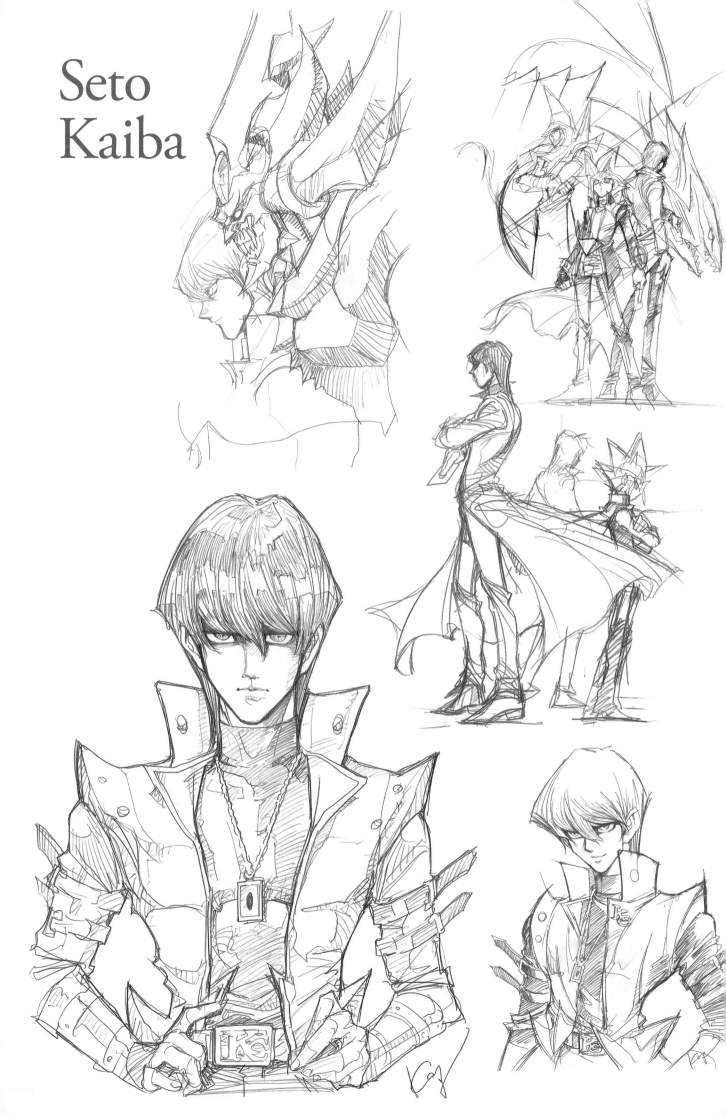

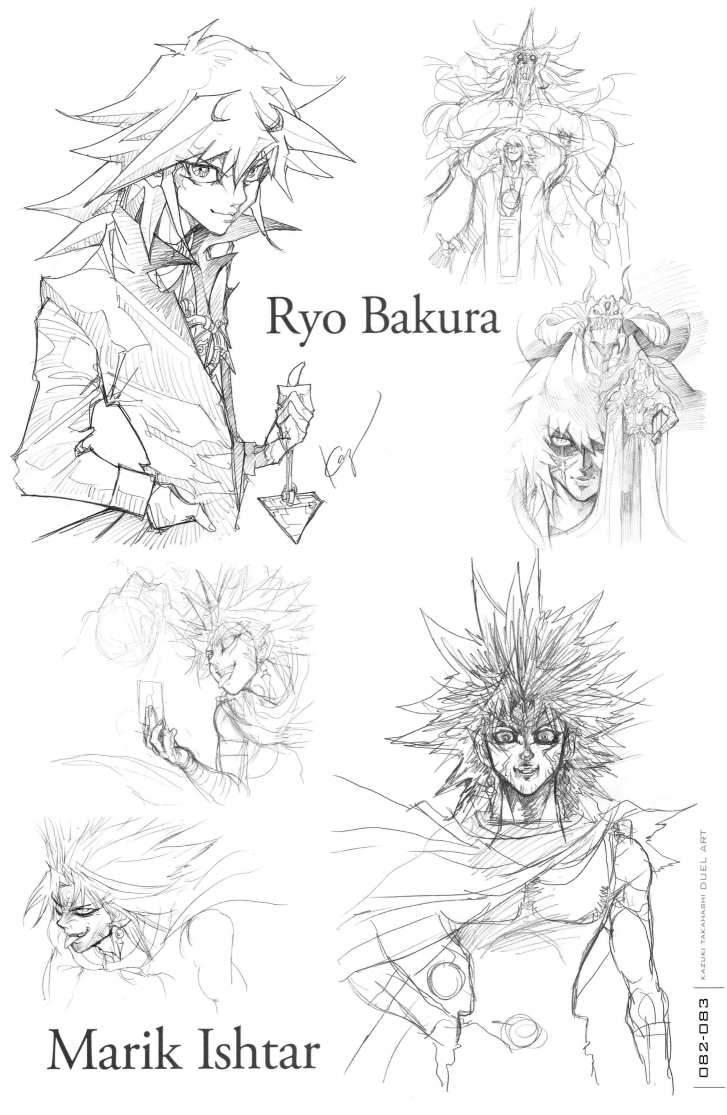

Ryo Bakura

Marik Ishtar

Ishizu Ishtar

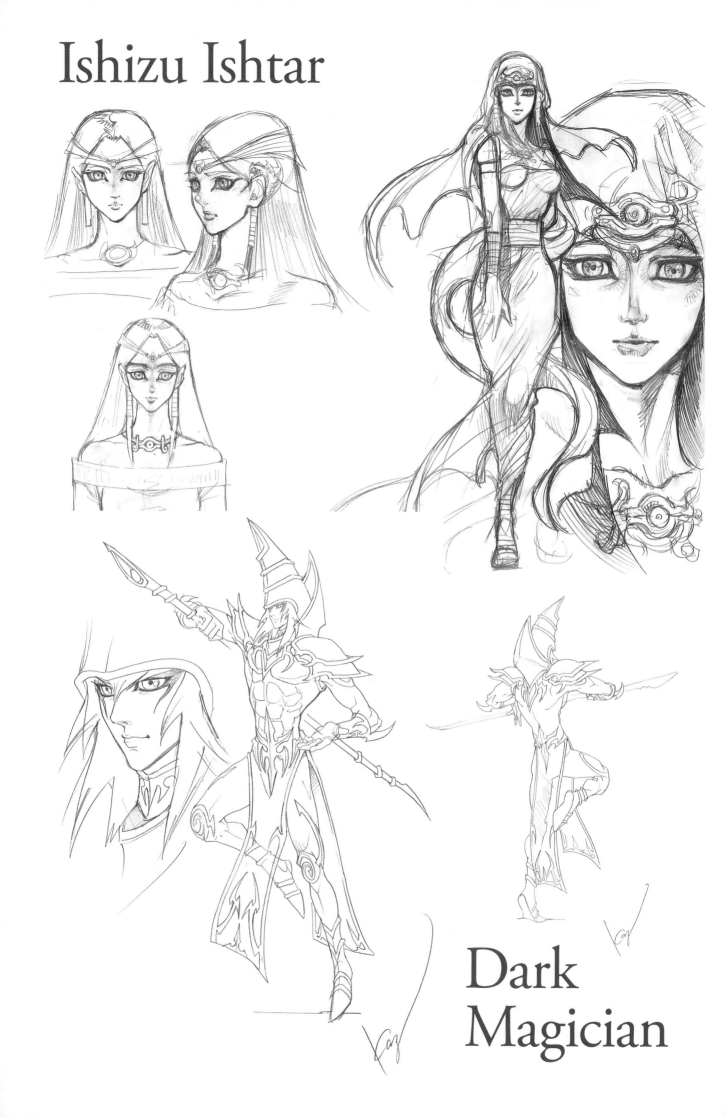

Dark
Magician

Dark
Magician
Girl

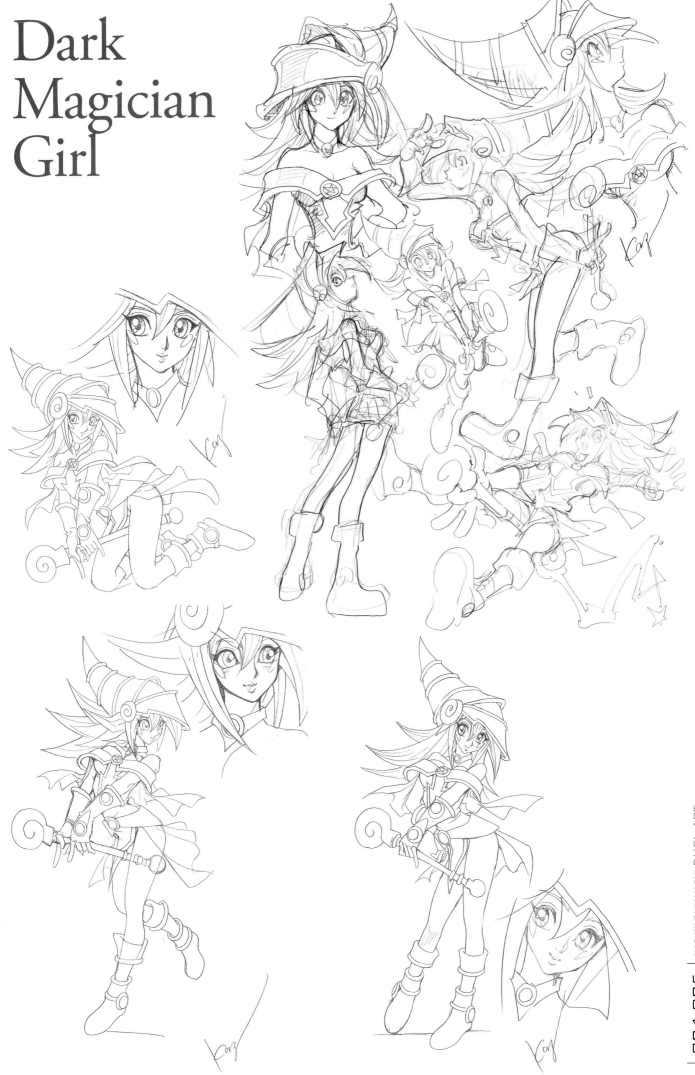

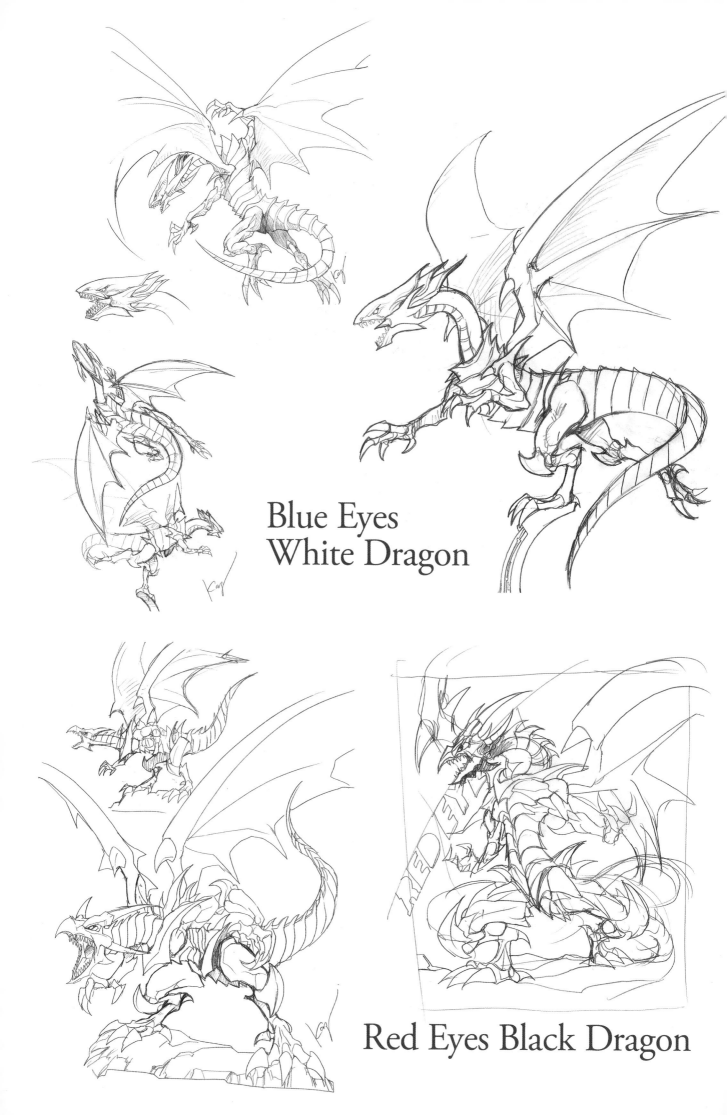

Blue Eyes
White Dragon

Red Eyes Black Dragon

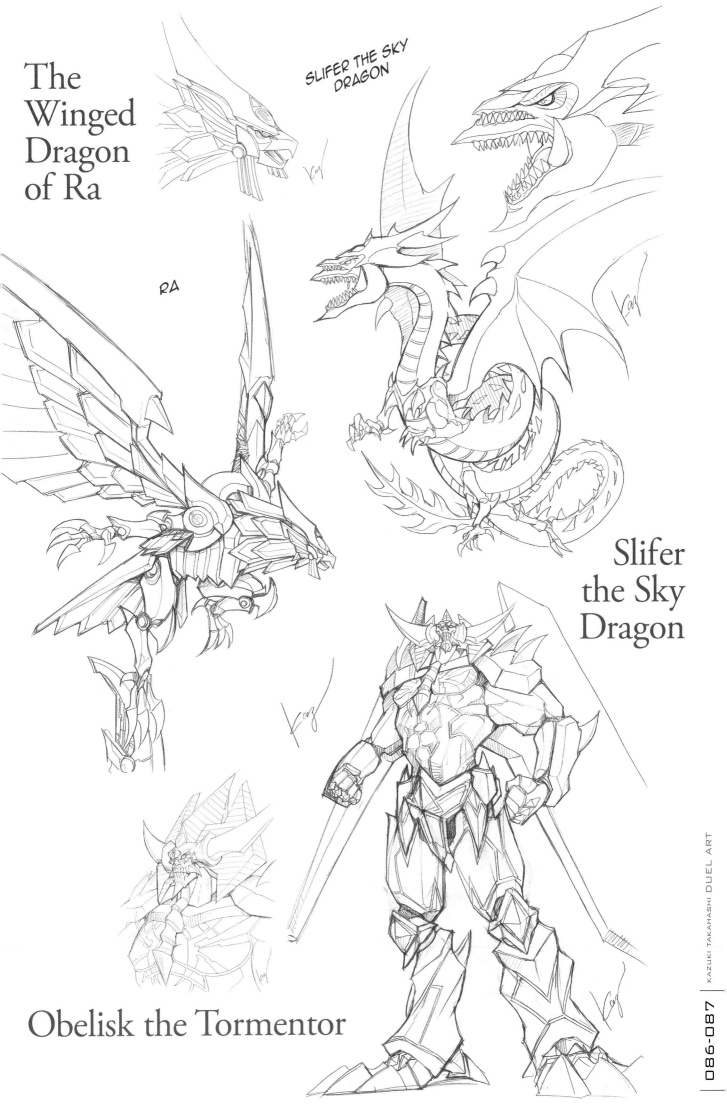

The
Winged
Dragon
of Ra

SLIFER THE SKY DRAGON

RA

Slifer
the Sky
Dragon

Obelisk the Tormentor

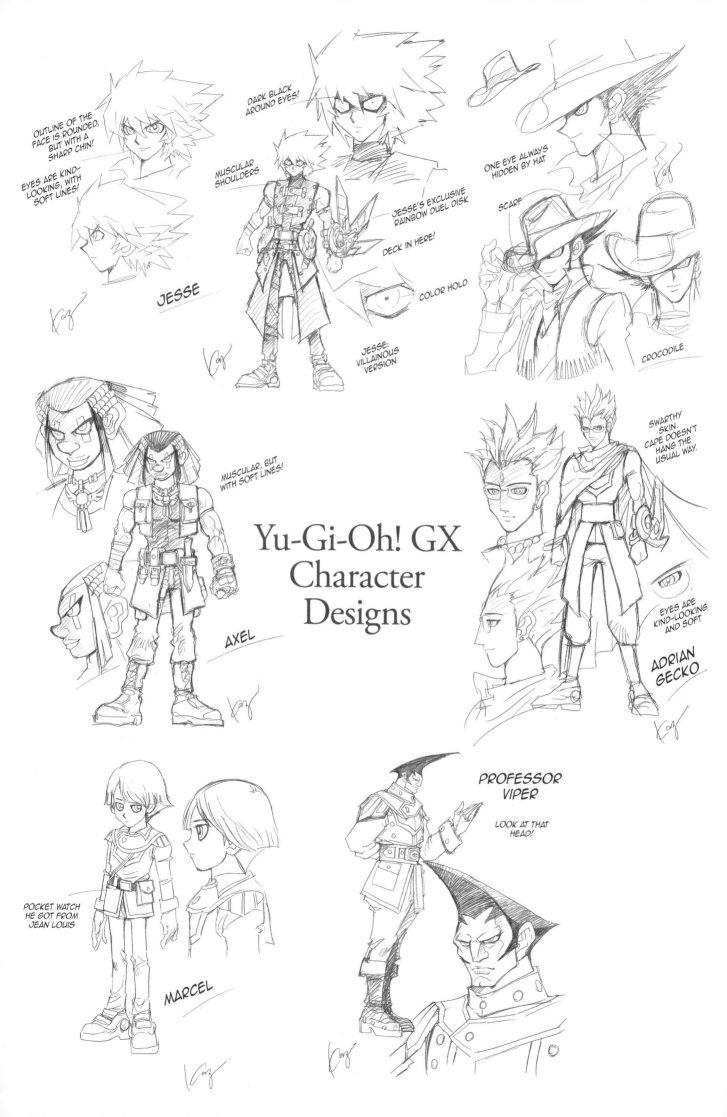

OUTLINE OF THE FACE IS ROUNDED, BUT WITH A SHARP CHIN!

EYES ARE KIND-LOOKING, WITH SOFT LINES!

JESSE

DARK BLACK AROUND EYES!

MUSCULAR SHOULDERS

JESSE'S EXCLUSIVE RAINBOW DUEL DISK

DECK IN HERE!

COLOR HOLD

JESSE: VILLAINOUS VERSION

ONE EYE ALWAYS HIDDEN BY HAT

SCARF

CROCODILE

MUSCULAR, BUT WITH SOFT LINES!

AXEL

Yu-Gi-Oh! GX Character Designs

SWARTHY SKIN. CAPE DOESN'T HANG THE USUAL WAY.

EYES ARE KIND-LOOKING AND SOFT

ADRIAN GECKO

POCKET WATCH HE GOT FROM JEAN LOUIS

MARCEL

PROFESSOR VIPER

LOOK AT THAT HEAD!

NEOS

MOLE OF
THE DEPTHS

AT FIRST, IT IS A
DRAGON SPIRIT.
THEN, ALONG WITH
EVIL INTENTIONS,
HUMAN (MALE/
FEMALE) FACES RISE
TO THE SURFACE.

YUBEL

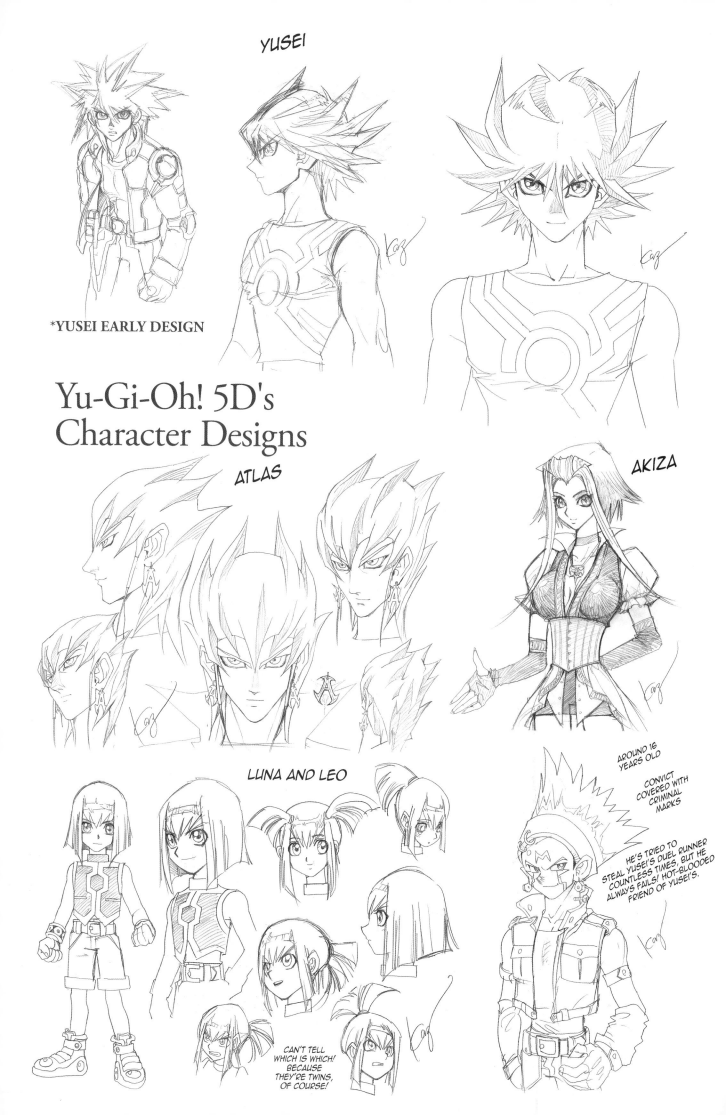

YUSEI

*YUSEI EARLY DESIGN

Yu-Gi-Oh! 5D's Character Designs

ATLAS

AKIZA

LUNA AND LEO

AROUND 16 YEARS OLD

CONVICT COVERED WITH CRIMINAL MARKS

HE'S TRIED TO STEAL YUSEI'S DUEL RUNNER COUNTLESS TIMES, BUT HE ALWAYS FAILS! HOT-BLOODED FRIEND OF YUSEI'S.

CAN'T TELL WHICH IS WHICH! BECAUSE THEY'RE TWINS, OF COURSE!

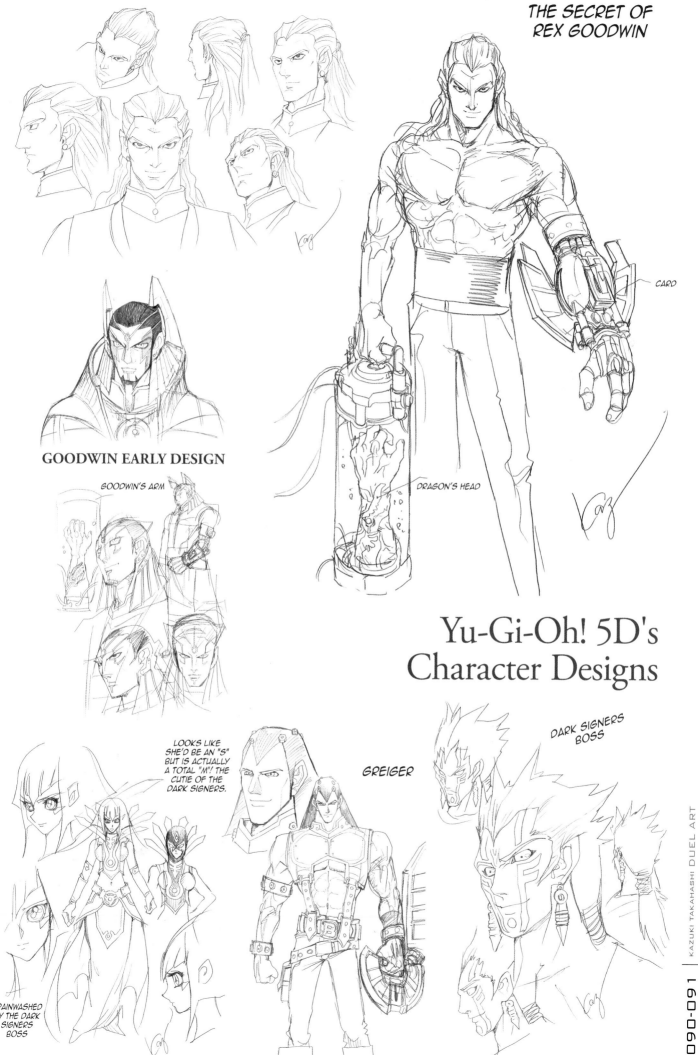

THE SECRET OF REX GOODWIN

CARD

DRAGON'S HEAD

GOODWIN EARLY DESIGN

GOODWIN'S ARM

Yu-Gi-Oh! 5D's
Character Designs

LOOKS LIKE SHE'D BE AN "S" BUT IS ACTUALLY A TOTAL "M"! THE CUTIE OF THE DARK SIGNERS.

GREIGER

DARK SIGNERS BOSS

BRAINWASHED BY THE DARK SIGNERS BOSS

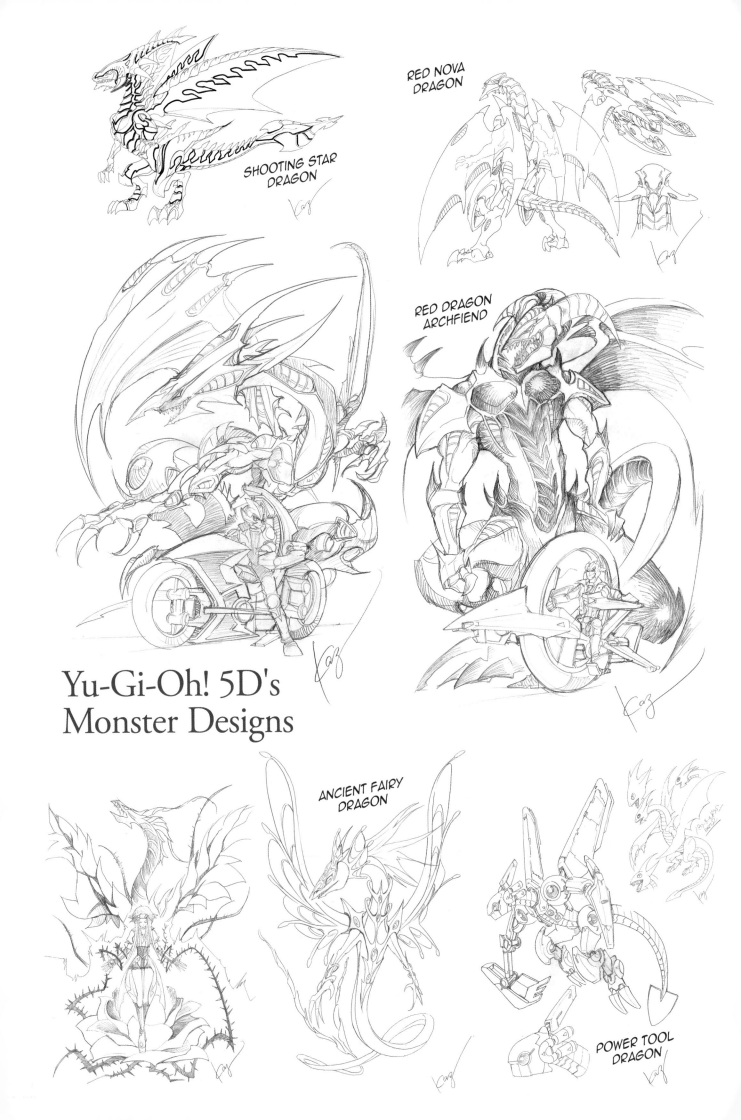

SHOOTING STAR
DRAGON

RED NOVA
DRAGON

RED DRAGON
ARCHFIEND

Yu-Gi-Oh! 5D's
Monster Designs

ANCIENT FAIRY
DRAGON

POWER TOOL
DRAGON

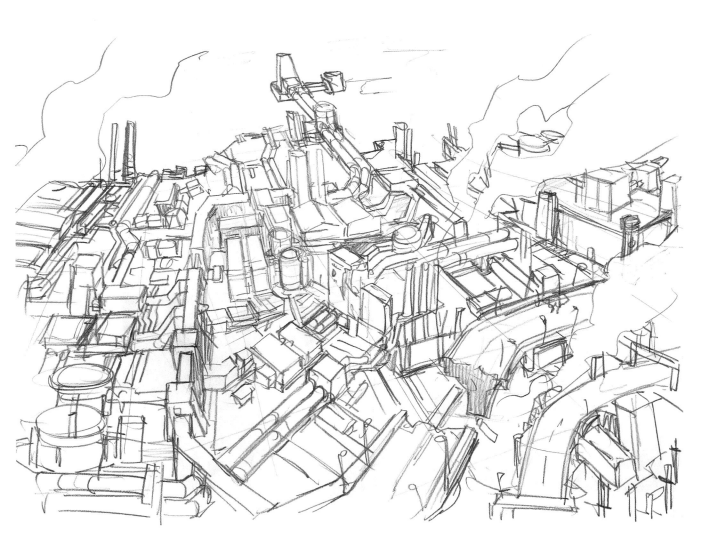

Yu-Gi-Oh! 5D's Background Designs

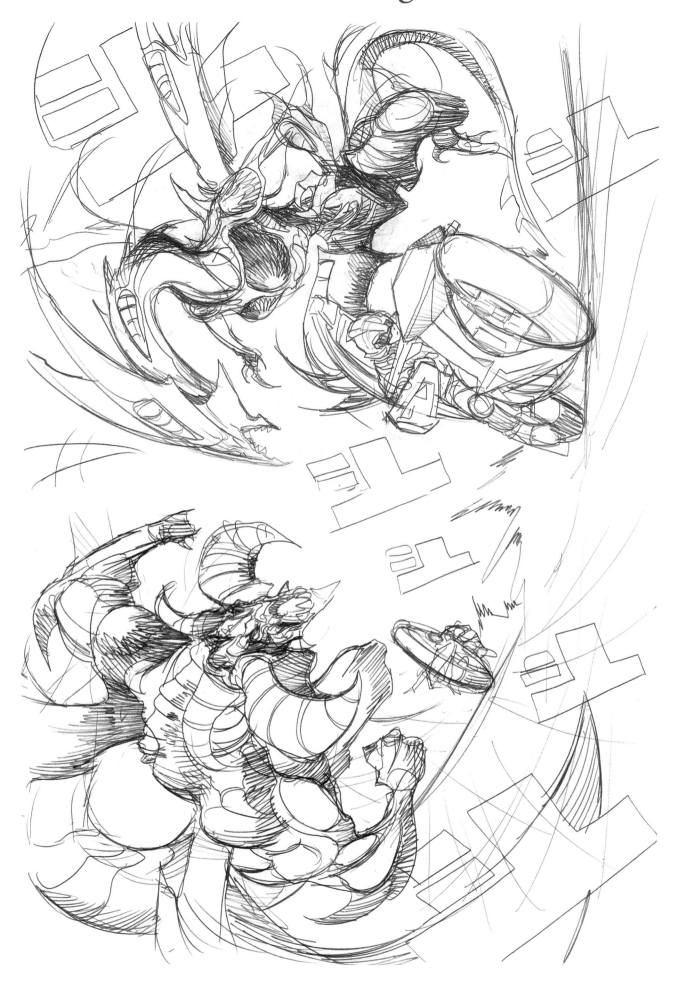

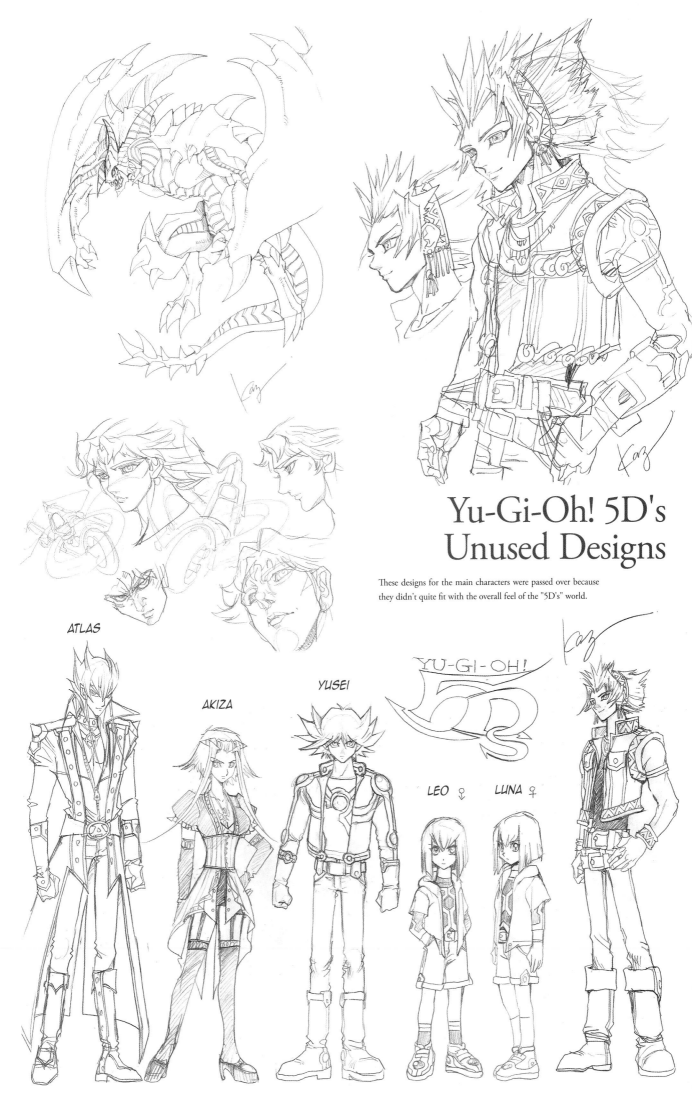

Yu-Gi-Oh! 5D's Unused Designs

These designs for the main characters were passed over because they didn't quite fit with the overall feel of the "5D's" world.

ATLAS

AKIZA

YUSEI

YU-GI-OH!
5D's

LEO ♂ LUNA ♀

"STAR"

Yu-Gi-Oh! ZEXAL
Character Designs

RIVAL CHARACTER

BASICALLY A "KAIBA-LIKE" CHARACTER!

HE'S JUST A BOY, SO HIS BODY IS ONLY SIX "HEADS" HIGH.

ACTS LIKE AN ADULT.

DR. FAKER

INVENTOR OF THE SPHERE (TBD) FIELD.

Yu-Gi-Oh! ZEXAL
Monster Designs

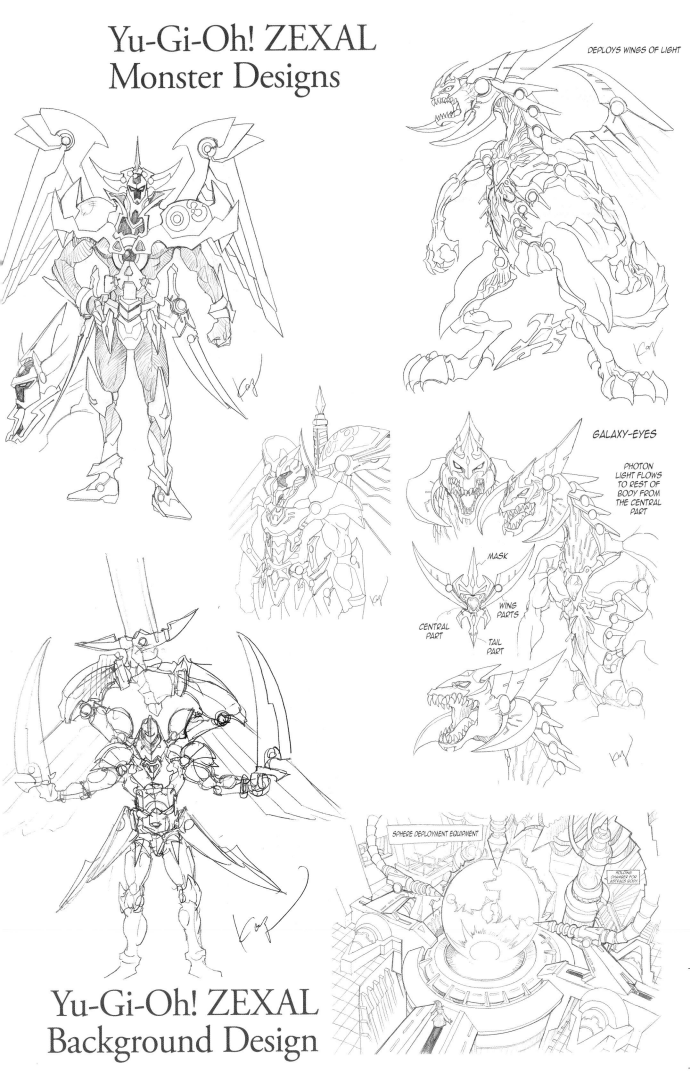

DEPLOYS WINGS OF LIGHT

GALAXY-EYES

PHOTON LIGHT FLOWS TO REST OF BODY FROM THE CENTRAL PART

MASK

WING PARTS

CENTRAL PART

TAIL PART

SPHERE DEPLOYMENT EQUIPMENT

HOLDING CHAMBER FOR ASTRAL'S BODY

Yu-Gi-Oh! ZEXAL
Background Design

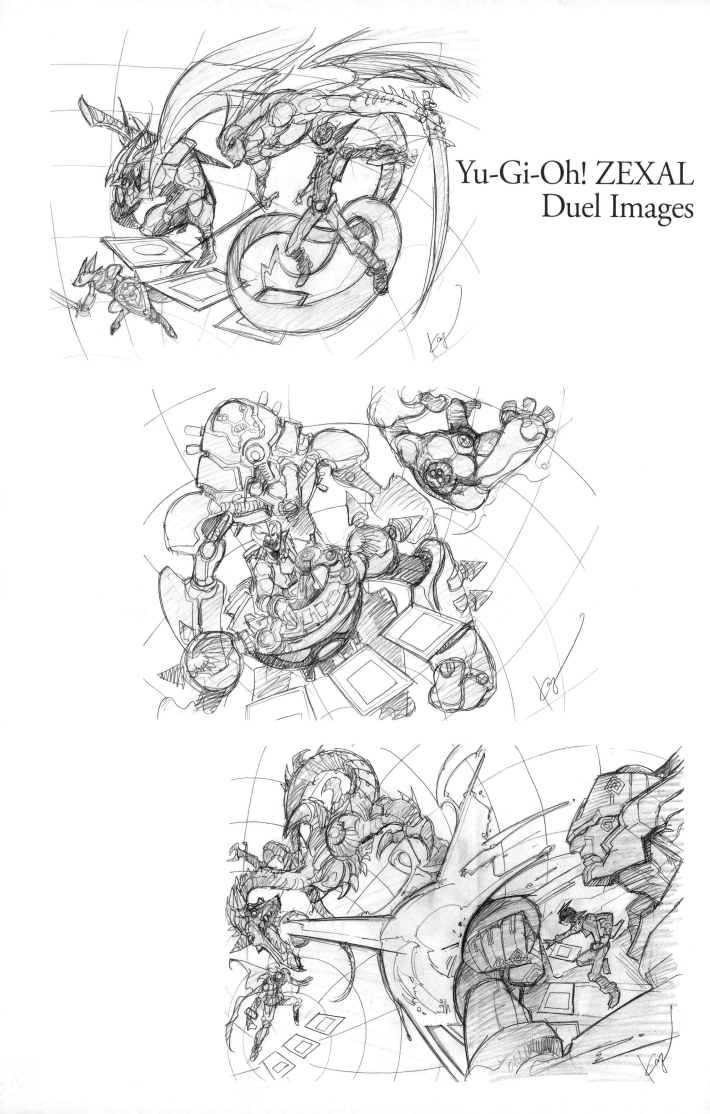

Yu-Gi-Oh! ZEXAL
Duel Images

ORIGIN

Of all the illustrations from the serialization period, these are truly the shining gems. They bring back memories of "Yu-Gi-Oh!"'s early stories. These Duel Art "origin" pieces were done in full color and with different techniques than the more recent art.

Origin

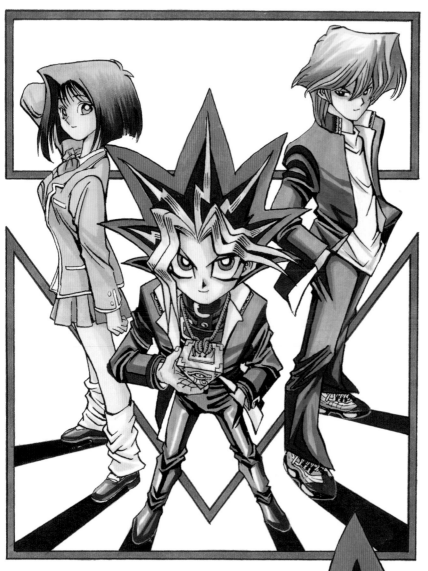

MAY 6TH, 1997:
Jump Comics Yu-Gi-Oh! Volume 2 Cover Illustration

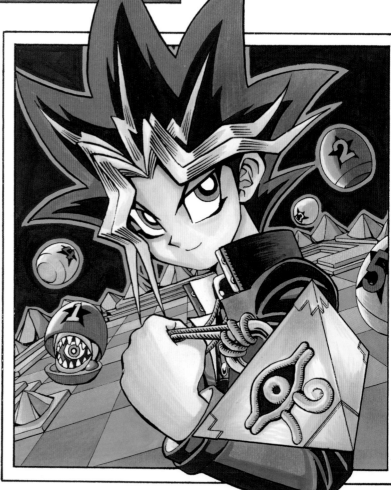

JULY 9TH, 1997:
Jump Comics Yu-Gi-Oh! Volume 3 Cover Illustration

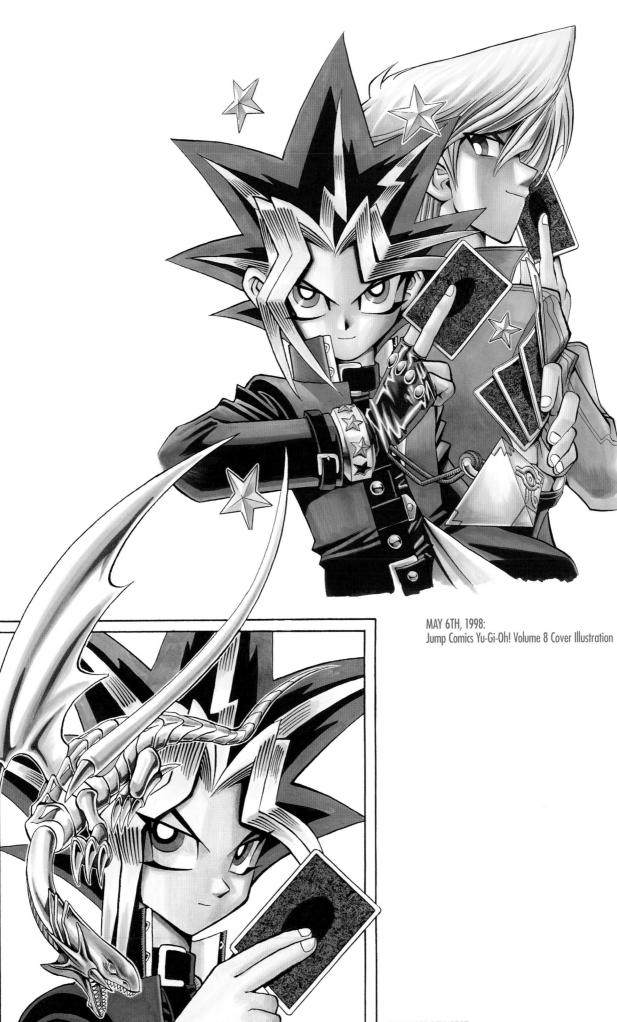

MAY 6TH, 1998:
Jump Comics Yu-Gi-Oh! Volume 8 Cover Illustration

NOVEMBER 9TH, 1997:
Jump Comics Yu-Gi-Oh! Volume 5 Cover Illustration

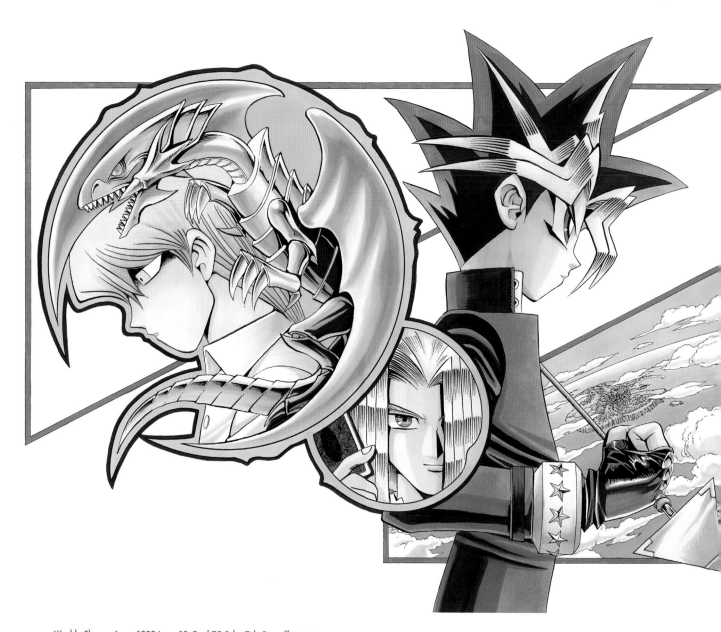

Weekly Shonen Jump 1998 Issue 18: Duel 75 Color Title Page Illustration

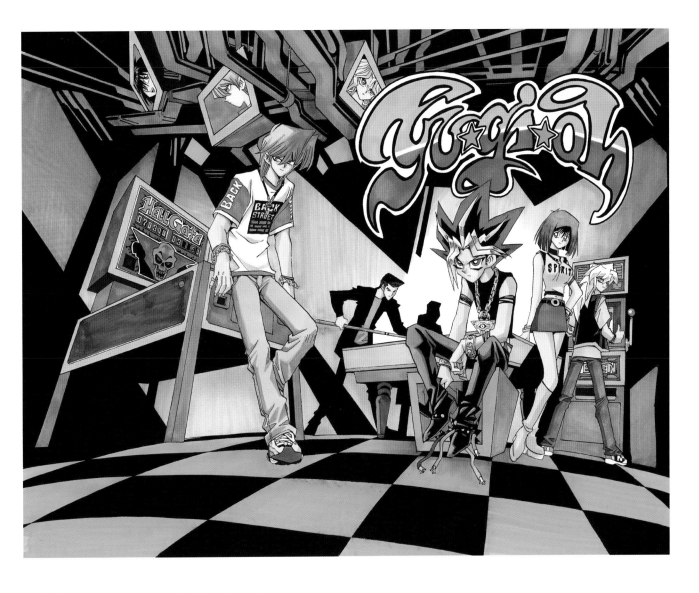

Weekly Shonen Jump 1999 Issue 31: Duel 134 Color Title Page Illustration

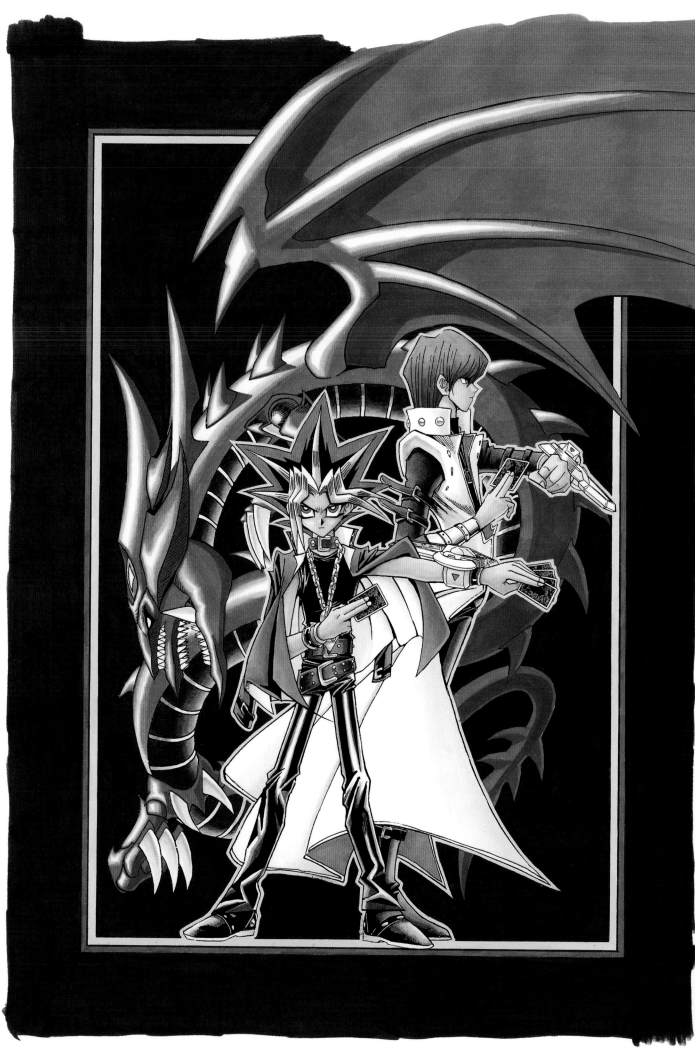

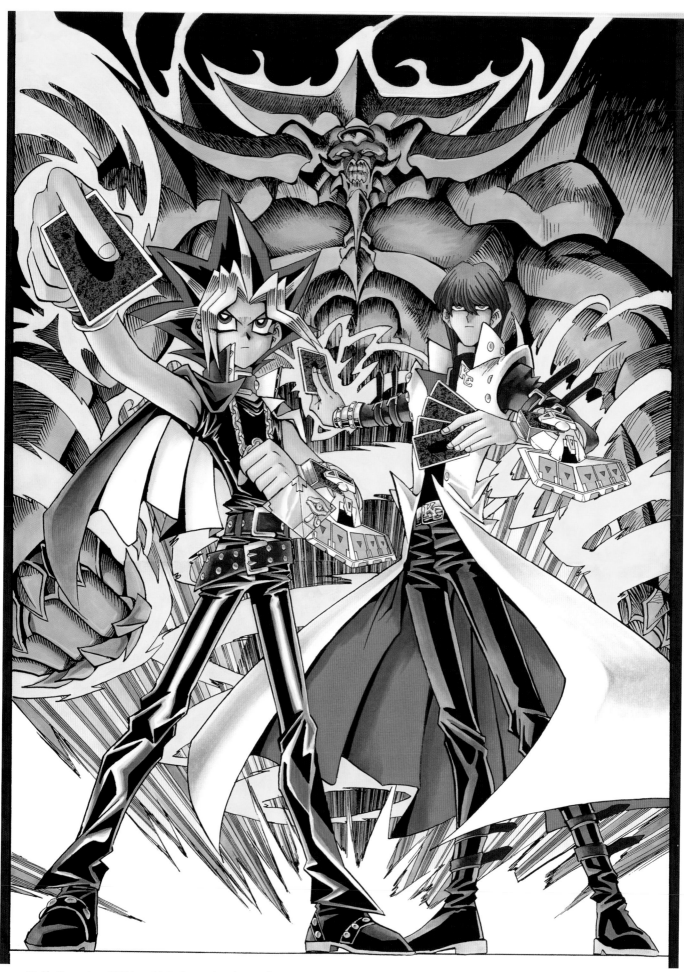

Weekly Shonen Jump 2000 Issue 36: Duel 185 Color Title Page Illustration

KAZUKI TAKAHASHI DUEL ART

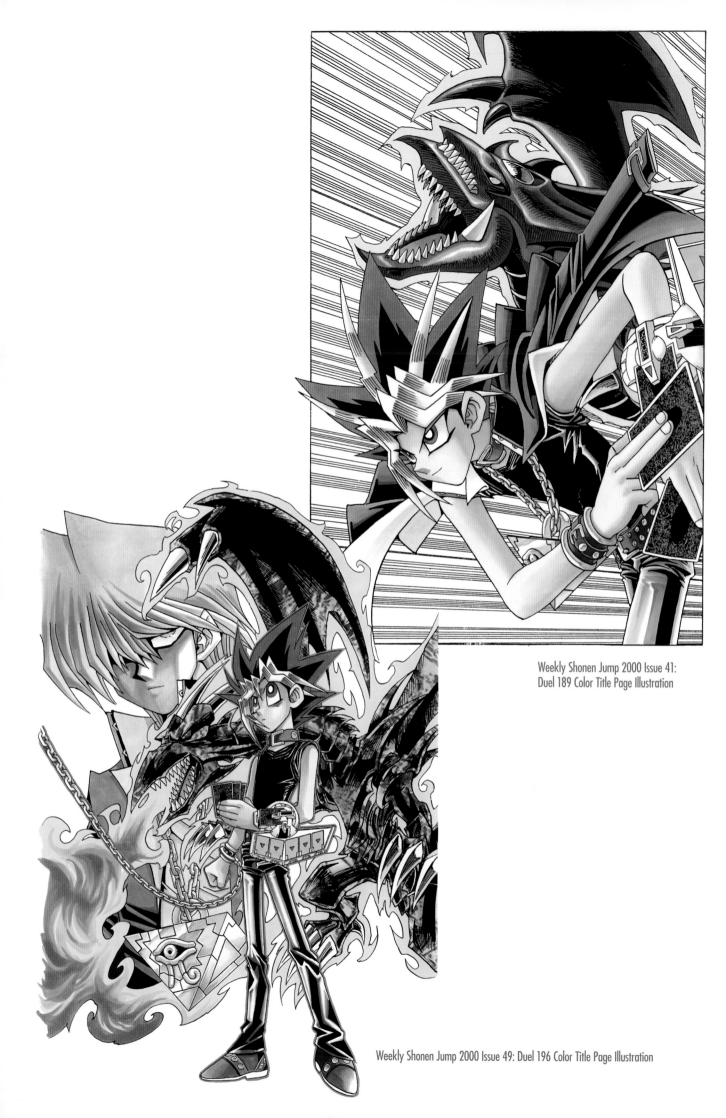

Weekly Shonen Jump 2000 Issue 41:
Duel 189 Color Title Page Illustration

Weekly Shonen Jump 2000 Issue 49: Duel 196 Color Title Page Illustration

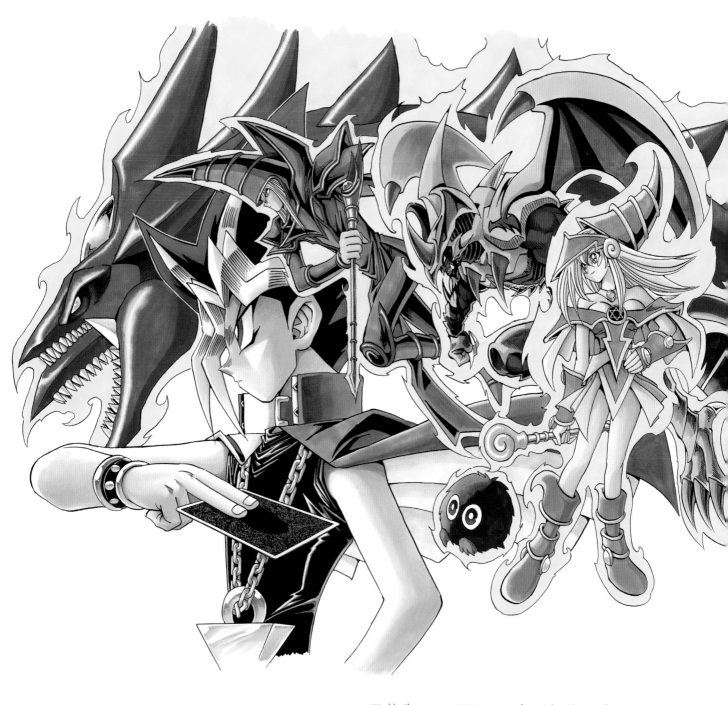

Weekly Shonen Jump 2001 Issue 1: Duel 200 Color Title Page Illustration

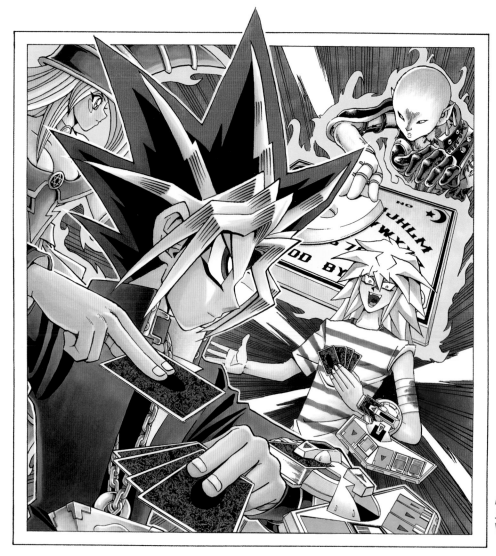

April 9th, 2001:
Jump Comics Yu-Gi-Oh!
Volume 23 Cover Illustration

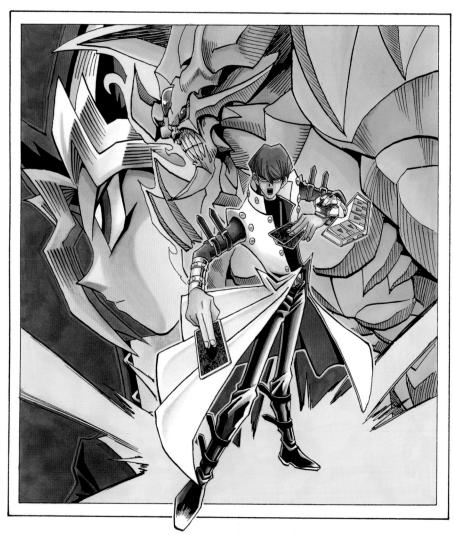

November 7th, 2001:
Jump Comics Yu-Gi-Oh! Volume 26 Cover Illustration

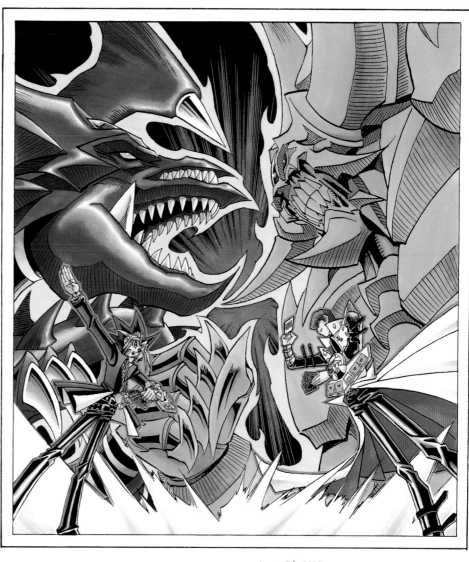

August 7th, 2002:
Jump Comics Yu-Gi-Oh! Volume 29 Cover Illustration

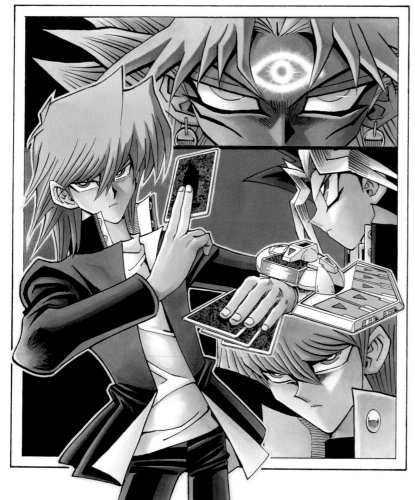

May 6th, 2002:
Jump Comics Yu-Gi-Oh! Volume 28 Cover Illustration

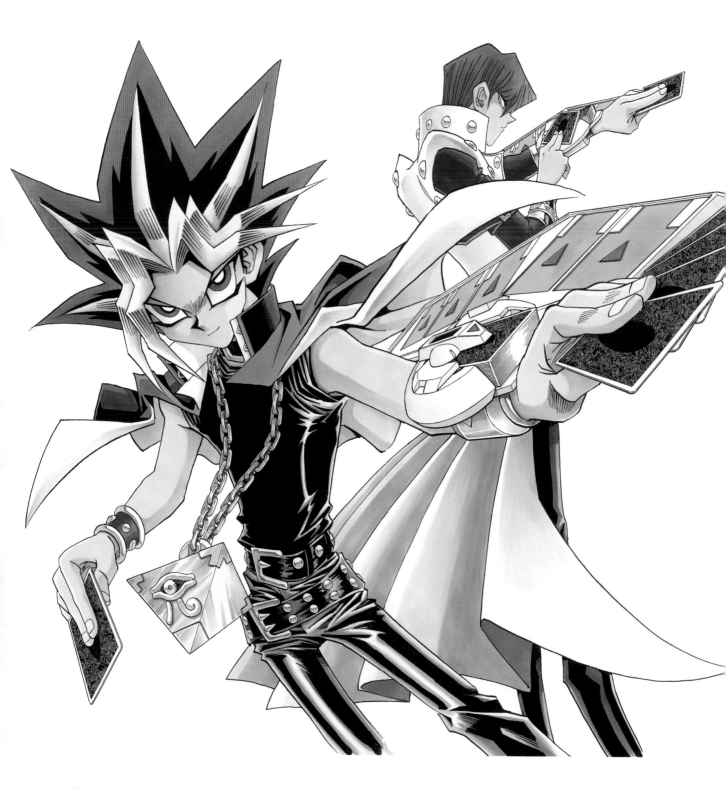

Weekly Shonen Jump 2002 Issue 9: Duel 251 Color Title Page Illustration

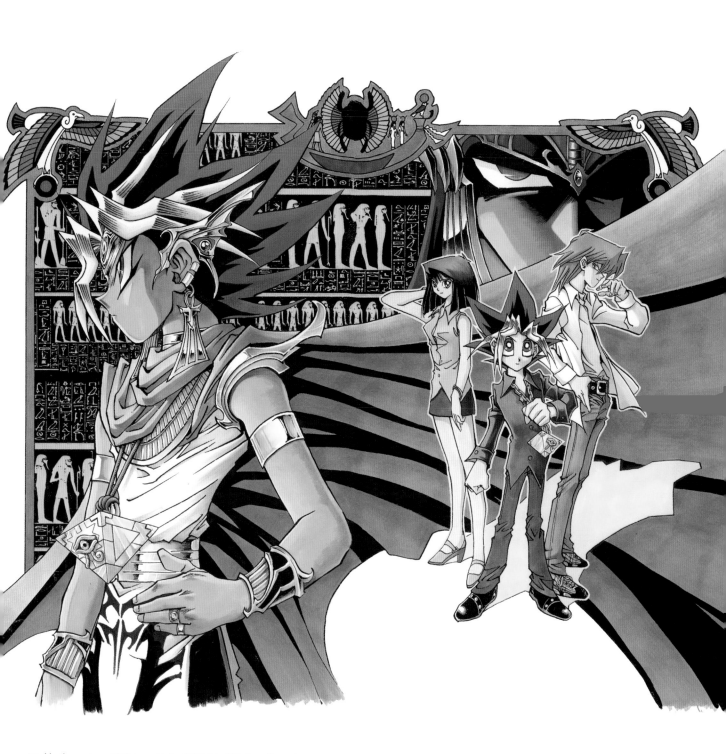

Weekly Shonen Jump 2002 Issue 46: Duel 279 Color Title Page Illustration

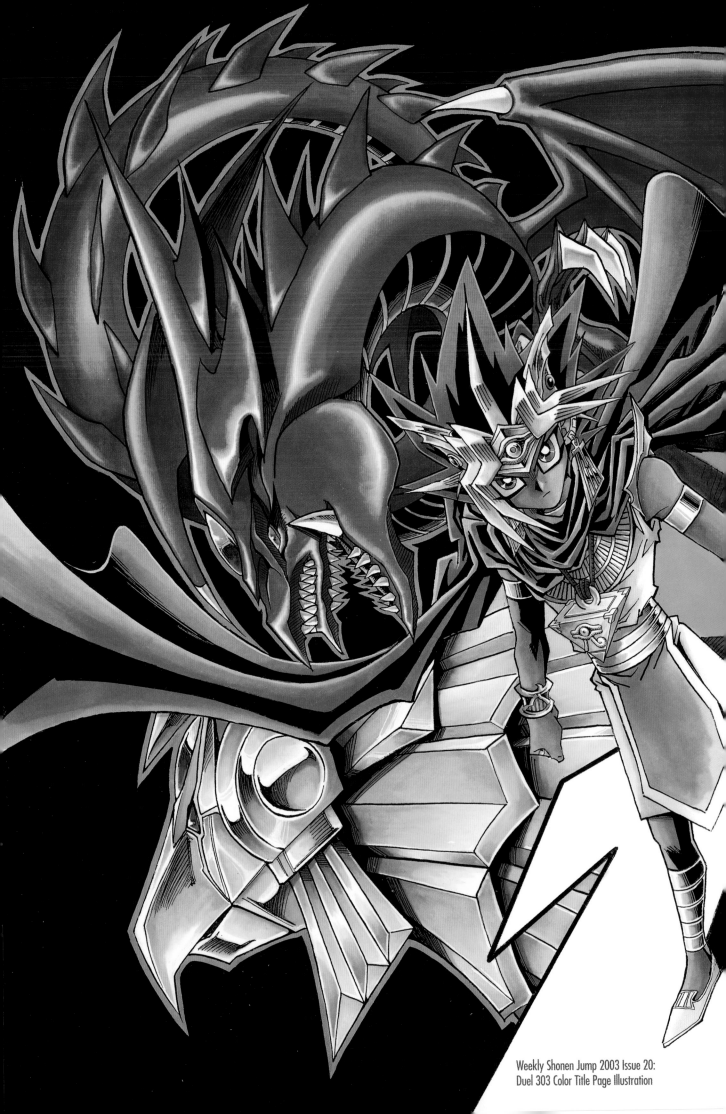

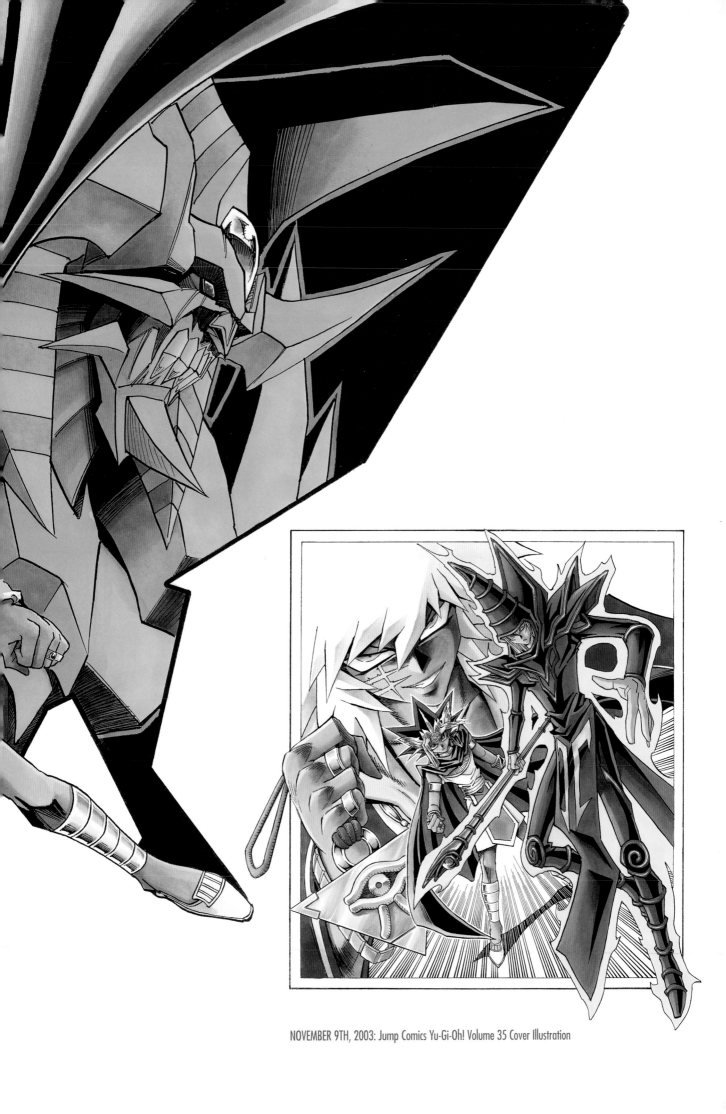

NOVEMBER 9TH, 2003: Jump Comics Yu-Gi-Oh! Volume 35 Cover Illustration

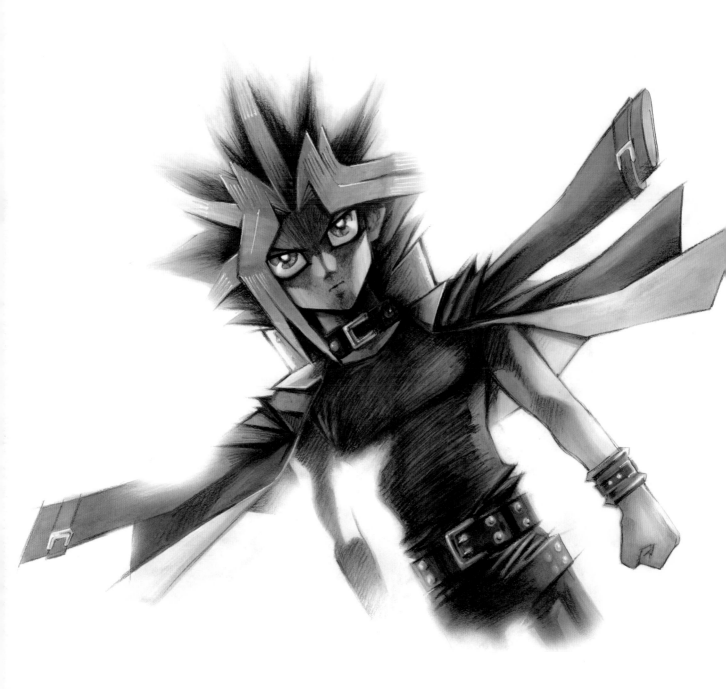

Weekly Shonen Jump 2004 Issue 15: Final Duel Color Title Page Illustration

CREATION

Kazuki Takahashi himself explains the creative process behind his "Duel Art". He also speaks with us about everything from the time he picked up drawing to the advent of his life's work. The techniques and history behind the "creation" of Duel Art are laid bare here.

- Creation -

DUEL ART
PROCESS OF DUEL ART

Here, the artist himself - Kazuki Takahashi - shows us the creative design process behind two of the amazing illustrations included in this very book.

Rough of Slifer the Sky Dragon

rough

Designing this composition for the OCG (Official Card Game) begins with a rough sketch drawn with a mechanical pencil. Tinting is also added at this stage.

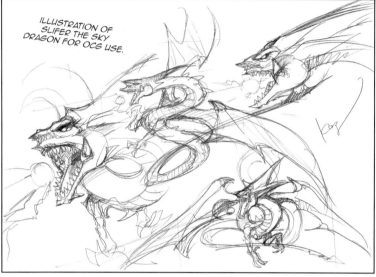

ILLUSTRATION OF SLIFER THE SKY DRAGON FOR OCG USE.

1.

I begin with a rough on copy paper. "Form" is extremely important, especially when it comes to dragons, so at this stage I include a number of different poses.

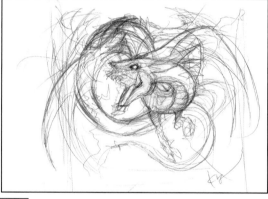

2.

With the general composition decided, I begin to sketch out the rough while adjusting his form bit by bit.

3.

I begin to flesh out the design with the rough sketch as a basis. Drawing in "effects" increases the overall intensity of the drawing. At this stage, I have the composition and color scheme decided.

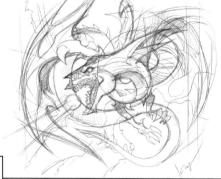

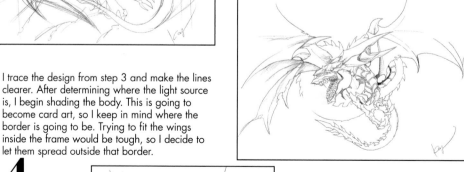

I trace the design from step 3 and make the lines clearer. After determining where the light source is, I begin shading the body. This is going to become card art, so I keep in mind where the border is going to be. Trying to fit the wings inside the frame would be tough, so I decide to let them spread outside that border.

4.

5.

I carefully trace the image from step 4. Balance is important, so I enlarge the left wing ever so slightly, making it a bit deformed.

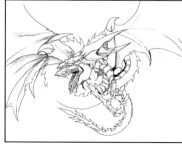

6.

I take the drawing from step 5 (on copy paper) and scan it into the computer at a resolution of 300 dpi. All work from this point on is done on the computer. I adjust the lines in Adobe Photoshop and color the image with Painter.

Background of Slifer the Sky Dragon
background

Slifer's background is filled with drifting thunderheads. The effects and the dragon's body will stand out that much more against this darkened background.

7.

While keeping an eye on the resources available, I decide on a main color for the background. I separate the layers and add gradation to the background.

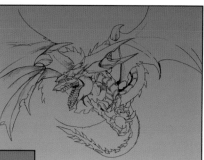

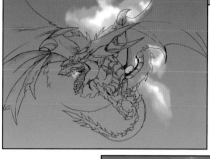

8.

I carefully add clouds in the background. Oil paint is used to make the clouds appear thicker. Deciding where and how to make light shine through the clouds, based on Slifer's overall form, is key.

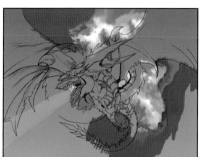

10.

I darken the entire image so that Slifer will stand out more. You can see the beginning of his attack effect - "Thunder Force" - coming out of his mouth.

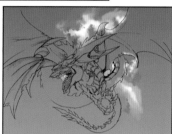

9.

Oil paint has a tendency to lay on thick and opaque, so I subtly adjust the clouds to have lower opacity.

11. "Thunder Force" lights up the darkness, so I draw in the outline of its path.

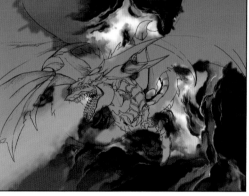

12.

I draw in the thunderheads. Light is supposed to be hitting the clouds, so I adjust the shading to give them the illusion of depth.

13. The background is finished.

Coloring Slifer the Sky Dragon
color

Finally, color is added to Slifer. His body really begins to pop out through careful attention to shading.

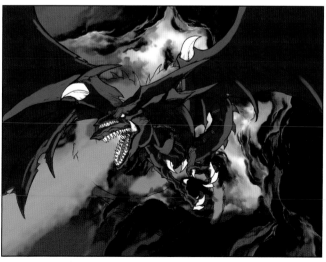

14. I add another layer and fill in Slifer's entire body with color.

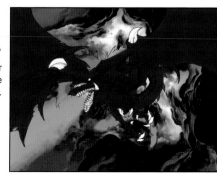

15. I paint brighter colors onto the parts being hit by light. Slifer's body now stands out even more from the background.

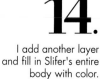

16.

I add in more details.

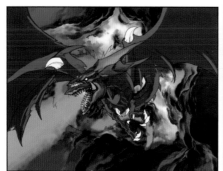

17.

Slifer has a lot of sharp angles on his body, so careful shading can make him appear more three-dimensional. His relatively round torso section has a nice mix of straight and curved lines.

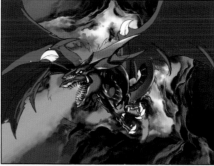

I work on the wings.

18.

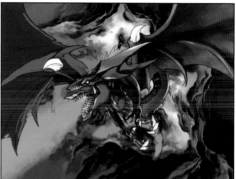

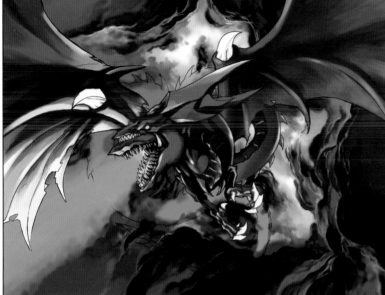

20.

Slifer's body is complete. Careful adjustment of the shading on the "close" and "far" parts of his body makes him seem more three-dimensional.

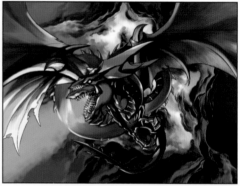

19.

The left wing will be illuminated by the nearby "Thunder Force" attack, so I make it brighter.

21.

I add in the "Thunder Force" effect.

22.

I refine the background.

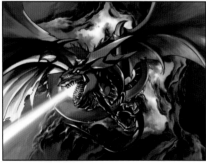

23.

Adding lightning effects completes the image.

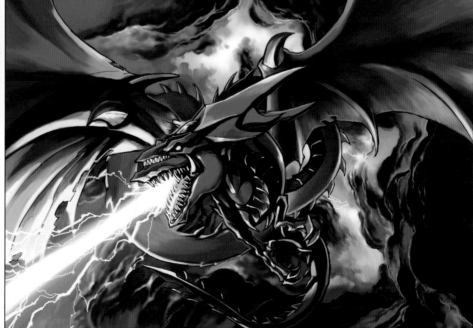

Rough of The Two Yugis

rough

In order to find the right composition to best show the "distance" between these two, I tried a number of different character angles, including an Atem from the front and even a full-on bird's-eye view.

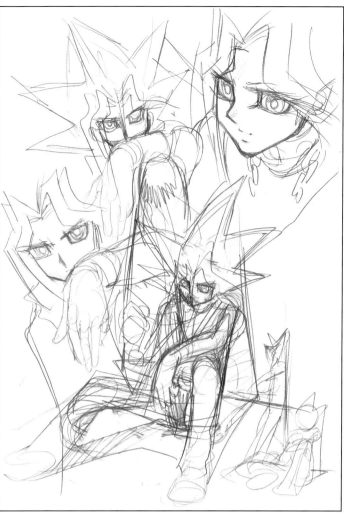

I try several expressions in these rough sketches. After choosing my favorite among them, I begin to think about the poses and overall composition. **1.**

2.

I draw the two Yugis. This rough sketch shows the composition I settled on.

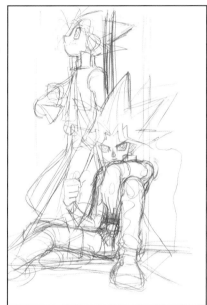

3.

This is subtle, but by having the "other" Yugi obscure his mouth with his hand, his expression is unreadable, but that kind of seemed like a good thing to me. That's how I decided on this pose.

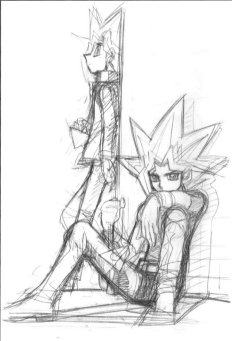

4.

I trace and finalize the lines by using a light table. The mechanical pencil I used is a 0.5, 2B.

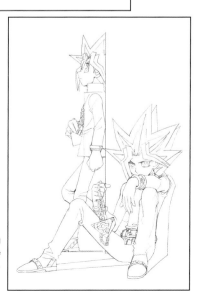

5.

I scan the image at a resolution of 300 dpi. The digital work begins here.

Coloring The Two Yugis

color

Coloring begins with the skin on their faces and hands, because those parts are responsible for portraying their expressions and overall moods. I also go over the details on the Millennium Puzzles that each of them are holding.

I start with the two Yugis' skin color. I believe that expressions are the most important part of drawing characters, so I always start with the face.

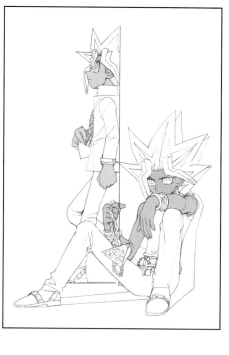

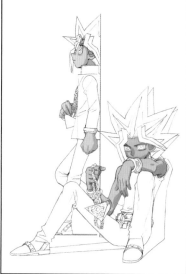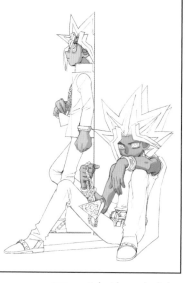

7. I decide on the light source and shade appropriately.

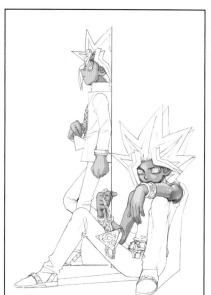

8. Wherever light is hitting, I make those areas brighter.

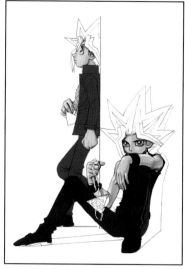

11. I add another layer and paint on their clothing. With school uniforms as a base, I color them slightly darker.

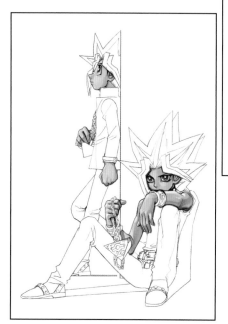

9. Bit by bit, I distinguish the shaded parts from the illuminated parts.

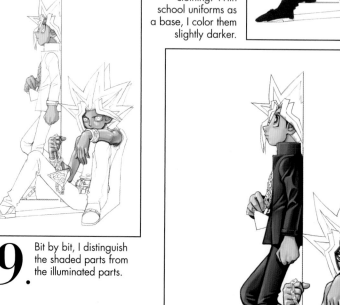

10. Their faces and other areas with exposed skin are finished.

12. I add brighter colors, keeping in mind where light should be hitting.

13.

Their clothing is largely finished, and I begin coloring their Millennium Puzzles.

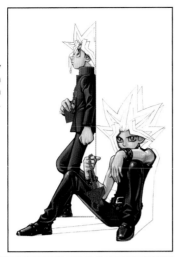

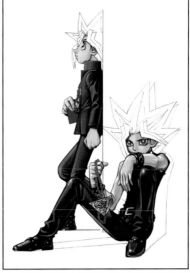

14.

The Millennium Puzzles are finished.

15.

I color their hair. Their full forms have come into view.

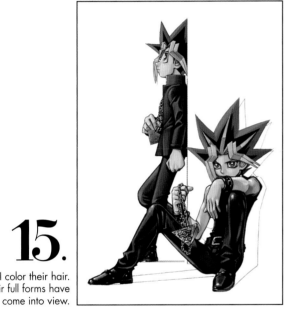

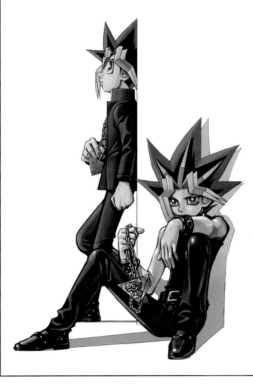

16.

Shadows are the final step. This illustration of the two Yugis is complete.

tools

Kazuki Takahashi has produced a ton of Duel Art, and here we see the workspace and materials he has used to do it.

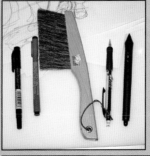

Mechanical pencils are the main tools used for drawing rough sketches. Most of the rest of the work is done on the computer, so other non-digital tools are kept to a minimum.

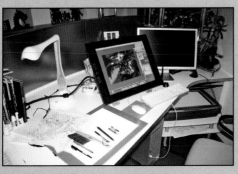

This wide desk has the tools for making rough sketches as well as a PC and a scanner. Everything needed to produce Duel Art can be found in this space.

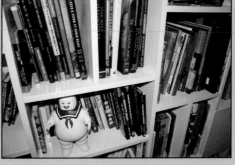

One entire wall of the workshop is covered with bookshelves. Both Japanese and Western reference books fill these shelves to capacity.

THE BEGINNING OF DUEL ART

We talk with Kazuki Takahashi about how he got into art, as well as his attitude toward his ever-changing yet always creative art style during the period of his serialization.

THE JOY OF BRINGING PEOPLE TOGETHER AND DISCOVERING DRAWING AS A CHILD

What originally inspired you to start drawing?
TAKAHASHI: I've drawn as long as I can remember. Since kindergarten, maybe? I was small and relatively weak at the time, and I never had much of an appetite at lunchtime. So I spent my free time drawing pictures. My friends would gather around in order to see what I'd drawn. The joy that gave me was what inspired me to keep drawing.

What sort of pictures did you draw as a child?
TAKAHASHI: As an elementary school student, I was always drawing my favorite anime characters, especially the muscular ones from "Tiger Mask" (*1). Limited animation (*2) was in vogue at the time, which meant that movement was expressed with sharply-drawn images and a small number of animation cels. That was really cool.
But I noticed something strange when drawing pictures of "Tiger Mask". It was clear that a normal human face wouldn't fit properly inside that mask. When I tried to draw the protagonist with a face that would actually fit with the mask, it came out looking weird. Even so, I thought the "Tiger Mask" anime was just about the coolest thing.

So the mask in the anime was less human, more tiger?
TAKAHASHI: Right. It looked like a tiger's face. That was around the time I realized that design, form, and appearance are really important when drawing. Rather than a mask that could actually be worn, this sort of deformed yet refined mask was much more interesting. That's why, at the time, I was more into manga with stylized characters rather than realistic ones.
But when I started drawing my own manga, that preference for stylized designs became a hindrance. Animation artists can compensate for how stylized their characters are via movement and scene direction, but manga artists have to make do with still images. Reconciling that "gap", so to speak, was a real challenge for me when I started out.

I've heard you were also into "Ultraman" (*3).
TAKAHASHI: I loved it. When I was little, I wanted to grow up to be a monster designer for "Ultraman". I was also a fan of Tsuburaya Productions' (*4) series in general. Getting to see a new monster every week in the new episode of "Ultraman" was thrilling for me as a kid.

So constantly debuting new monsters in "Yu-Gi-Oh!" must have been a result of those fond memories?
TAKAHASHI: That's right. It was always an experience I loved so much, so I figured my readers would also get a thrill out of all the new monsters I was showing them. Well… chapters of "Yu-Gi-Oh!" rarely only had a single new monster. (laughs)

So what else did you draw back then?
TAKAHASHI: I drew "Space Battleship Yamato" (*5) all the time. Even now I can draw it from memory. There was also "Mazinger Z" and "Devilman" (*6). But at the time, my templates were images from the anime series, not the manga versions.
As a high school student, I even went and made a finished cel drawing of "Yamato", starting with a line drawing, then a tracing, and then coloring. I was aiming to be an animator back then, and as a second-year student in high school, I took the entrance exam for a production company. I was thinking, "If I pass this, I'll just quit school!" (laughs) But I ended up failing.

Did anyone in particular teach you how to be an illustrator?
TAKAHASHI: Nah. At least I don't remember anything like that. I just never stopped practicing until I was satisfied. I'd reflect on

work that I'd just spent a ton of time on and realize that it wasn't very good, or that something was just "off". But the fact that I could even tell that it was off was a sign that I was improving, little by little.
Repeating that process over and over eventually led to drawings that weren't half-bad. If you want to know my "secret", it's just to keep drawing until you like what you see. But to be honest, when I look back at the "Yu-Gi-Oh!" manga now, the drawings look ridiculous. (laughs)
Even now, when drawing monsters, I initially experiment with a variety of compositions and perspectives. I find it hard to create something I can be proud of without taking the time to do that first.

COMPLETING THE DARK FANTASY SAGA THAT IS "YU-GI-OH!"

When did you first start drawing manga?
TAKAHASHI: In my third year of elementary school. It was a really crappy 8-page gag manga. I also made this silly little 20-page dojinshi [amateur-made magazine] with my cousin at the time.
Back then, shonen manga magazines often had ads for bicycles in the back, so I poured my soul into making a fake bike ad for our magazine. (laughs) I also used to borrow manga from the library a lot, and I remember being amazed at the work the pros were doing. Their backgrounds and characters were so detailed. I was convinced I'd never be good enough to become a professional manga artist.

When did you change your mind and decide to go for it?
TAKAHASHI: When I was 20. At the time, I was designing corporate logos and banners, but it was then that I started drawing a bunch of manga and bringing it to publishers.

Which manga inspired you the most?

The first issue of Takahashi's dojinshi. The back cover features a bicycle ad, and the double-page spread with previews of the next issue already has a notification that one series will be absent due to its author's sudden illness…

TAKAHASHI: I read so much manga as a kid. Just like kids today, I was "baptized" by the worlds of Fujiko Fujio. I especially liked Fujiko Fujio A-sensei's "Mataro ga Kuru!!" (*7). People often say they can see the effect "Mataro" had on the early parts of "Yu-Gi-Oh!".
What's really great about Fujiko Fujio is how they were able to showcase the extremes of "light" and "dark". The world of Fujiko F. Fujio-sensei's "Doraemon" (*8) is so wholesome, but then you have Fujiko Fujio A-sensei's "Mataro", which is so dark. Of course,

they would also influence each other and come together to make some really interesting series.

"Yu-Gi-Oh!" also features duality pretty heavily. Front and back; light and dark.
TAKAHASHI: Right. You have this protagonist who's usually pretty reserved, but he finds himself with a mysterious power that lets him transform. At the time, most manga and anime protagonists were muscleheaded brawlers, so the idea of a meek protagonist who could turn things around and use his powers to fend off bullies was pretty unique.
But we can't forget Hirohiko Araki-sensei's "JoJo's Bizarre Adventure" (*9). I was really inspired by the darkness in that series.

Did you have any non-manga inspirations?
TAKAHASHI: I was a fan of Tim Burton's movie "Edward Scissorhands" (*10), and that actually influenced Yugi's costume. I thought the lines and details of that sort of "bondage fashion" were really cool. "Yu-Gi-Oh!" begins in a school setting, but having an ordinary school uniform jacket with a T-shirt underneath would be boring. So I gave Yugi the bondage elements underneath the jacket...! Definitely unusual. (laughs)

The idea that an ordinary T-shirt would be boring goes along with the "stylized" sort of manga you mentioned earlier.
TAKAHASHI: "Star Wars" (*11) was another big one for me. The idea for the "solid vision system" Kaiba develops came from the scene where Chewbacca and C-3PO are playing chess with hologram monsters (*12).
When I eventually got around to visiting Skywalker Ranch (*13), I was sure to tell the staff there, "Without 'Star Wars', there would be no 'Yu-Gi-Oh!'". (laughs)

THE KAZUKI TAKAHASHI WAY OF CREATING CHARACTERS

How did you come up with the characters for "Yu-Gi-Oh!"?
TAKAHASHI: I start by deciding on their personalities; are they fundamentally good or bad? After that, I can begin designing their appearances.
Whether it's with monsters or characters, rounded forms tend to imply gentler personalities, while sharp angles show that the character is more aggressive. Similarly, a straight line over the top of the eye is for particularly egotistical characters, while a line under the eye is a sign that the character is more cooperative and dependent on others. Differing degrees of egotism translate directly into different visual forms.

I see. That's why the protagonist, Yugi, has lines under his rounded eyes.
TAKAHASHI: Exactly. Simply changing the location of those lines can determine whether a character is more likely to be aggressive, as opposed to one who tries to protect others. Also, the shape of the eye can express any number of different personalities.

"Yu-Gi-Oh!" is known for its characters' extreme hairstyles.
TAKAHASHI: That's so that any given character can instantly be recognized based on their hair alone. I consider hairstyle to be the most important element of a character's overall "form", and it really defines a design all on its own. Yugi's hairstyle resembles an open hand with hints of a dried autumn leaf. I consciously tried to make it very "shonen manga"-ish.
But I initially stressed out a bit about whether or not the two Yugis should really have the same hairstyle. Dark Yugi needed to have that exciting, shonen look, but that meant that normal Yugi would share the same overly-aggressive hairstyle. I actually made his hair red for the first color page in chapter 1. (laughs) I felt that I didn't have a choice, though, because the first color page of a manga has to really stand out.

Their hairstyles may be the same, but the two Yugis are clearly different people visually. The contours of their respective faces are definitely distinguishable.
TAKAHASHI: Their eyes and faces, yes. Also their noses and the way their hairstyles flow. All of those visual tweaks (besides the basic hairstyle) help communicate the personality transformation.

Where did you get the idea for the story of the "Yu-Gi-Oh!" manga?
TAKAHASHI: "Battle manga" are king when it comes to Jump series, but I thought it would be fresh and exciting to have the battles be games instead. That way, even a child can beat an adult.
Once I was serialized, coming up with a game every week was a pain, so when I finally decided to focus exclusively on the card game with battling monsters, it felt like I'd escaped from a cramped canal into the wide open ocean.
But the most important thing in the manga has always been the characters, including the protagonists. The cards that Yugi and friends use are never more than simple tools. I wanted readers to empathize with these characters who always had to overcome all sorts of challenges.

Is the character of Yugi Mutou based on anyone in particular?
TAKAHASHI: This may be a digression from the specific topic of design, but Dark Yugi's true identity, Atem, has a strong Tutankhamun (*14) motif. Tutankhamun's father, Akhenaten (*15), was a strong believer in the sun god Aten, as his name implies. But looking at Tutankhamun's name, we can see that he was named in part after the god Amun. It always seemed unnatural that he would follow a different god than his father, and in fact, many of the objects in his tomb were found to have Aten's sun symbol on them.
This is just my own theory, but I'm guessing that when Tutankhamun became pharaoh at such a young age, his priests and advisors defied his will, seized power, and manipulated him into promoting Amun as the popular deity, even though he likely wanted to follow in his father's footsteps... That's why I decided to make Dark Yugi's true name "Atem".

KAZUKI TAKAHASHI, THE DESIGNER

I imagine that the hardest part for you was designing new monsters week after week. How did you come up with them all?
TAKAHASHI: Monsters were never decided at the "name" [initial story proposal] stage. That wouldn't come until I prepared an official rough draft, and monsters' appearances would change based on the situation in the story and the characters' personalities. For example, in the middle of duels, I might draw old mainstays with an unexpected level of detail. But sometimes the strongest-looking, "trump card" monsters could be improved by removing detail. Having a lot of lines doesn't necessarily translate to strength. I would also always try to imagine how the readers might be feeling at a given moment. If I thought they'd be saying, "We need something cool to pop out and save the day!" then I would go ahead and draw a really cool monster.

I'm always impressed at how you manage to produce those cool monster designs just when we're needing them most...
TAKAHASHI: No matter the monster, there's always a way to make it look cool, depending on the angle it's shown at. Luckily, it was around when I was starting out that McFarlane Toys (*16) began putting out the high-quality "Spawn" (*17) figure line. There were plenty of times when I'd get ideas for monster designs by staring at some of those figures.
Then of course there was "Ultraman" and other tokusatsu shows I loved as a child. I'd remember how excited I was while watching those shows and do my best to inject some of that charm into my own monster designs.

So you enjoy designing monsters?
TAKAHASHI: Not just monsters. I like designing in general. I like to think of myself as a "designer", rather than just a manga artist. Even thinking about panel layout while doing manga requires a sense of design.

***8 "Doraemon":**

A science fiction manga from author Fujiko F. Fujio. Accident-prone boy Nobita is always running into trouble, but Doraemon saves the day with mysterious future technology from inside his belly pocket.

***9 Hirohiko Araki's "JoJo's Bizarre Adventure":**

A manga series than ran in Weekly Shonen Jump from 1987 to 2004. It continues its serialization today with a series called "JoJolion". The manga's protagonists, all nicknamed "JoJo", use "stands" that give them special abilities to help them battle against a variety of villains. The series' distinct style and fashion sense have inspired a number of other accomplished authors.

***10 Tim Burton's "Edward Scissorhands":**

A film released in 1990 by director Tim Burton, who is known for his unique worlds that blend Gothic style with horror and fantasy. The story is a tragic dark fantasy in which an artificially-created man with scissors for fingers comes to love a young girl but cannot find acceptance in society.

***11 "Star Wars":**

The space opera to end all space operas and a monumental achievement in the science fiction film genre. The series tells the story of the war between the Galactic Empire and the Rebel Alliance, as well as the struggle between the Jedi and their dark counterparts, the Sith.

***12 "Star Wars" chess:**

A game shown in "Episode IV: A New Hope" in which players control holographic pieces. The game is called "Dejarik" or sometimes "Vrax".

***13 Skywalker Ranch:**

The physical studio of "Star Wars" producer Lucasfilm. Besides offices, the location also houses sound design studio Skywalker Sound. The studio resembles a farm from the outside, hence its name.

***14 Tutankhamun:**

An ancient Egyptian pharaoh during the 18th dynasty who died in 1324 B.C. After his enthronement, he overturned his father's policies and re-established a state based on the worship of Amon-Ra (or "Amun"). However, he was only a boy at the time, so there are several theories as to what really sparked the upheaval.

***15 Akhenaten:**

An ancient Egyptian pharaoh during the 18th dynasty who died in 1330 B.C., and Tutankhamun's father. The "Amarna Revolution" he enacted ended Egypt's traditional polytheism in favor of a monotheistic state that worshipped Aten and Aten alone.

***16 McFarlane Toys:**

A toy company started in 1994 by "Spawn" author Todd McFarlane. The company started out with figures of comic book characters but has since moved into the realms of sports, games, and anime.

***17 "Spawn":**

A comic series by Todd McFarlane that began publication in America in 1992. The story follows Al Simmons, a covert operative for the CIA who makes a deal with a demon, becomes a dark anti-hero, and battles angelic warrior Anti-Spawn.

*18 Halation:

The phenomenon in photography wherein the surroundings of objects hit with light become white and almost foggy, like halos.

*19 Drew Struzan:

An American illustrator born in 1946. Struzan is a master of cinema art who's made posters for the works of George Lucas and Steven Spielberg as well as the "Harry Potter" series, among others.

*20 Alphonse Mucha:

A graphic designer of the Art Nouveau movement who died in 1939. He was known for his distinctive, elegant designs that often combined stars, flowers, jewels, and women, and which employed a lot of curved lines. "Zodiac" and the painting series "The Slav Epic" are among his masterpieces.

*21 Norman Rockwell:

An American painter and illustrator who died in 1979. He's known for portraying the lifestyles of average Americans. He produced over 2,000 works throughout his life, but sadly, a large number of them was lost in a studio fire in 1943.

So you see the very layout of a single page as a design in and of itself?

TAKAHASHI: Yes, the page itself is a design. But when doing manga, one also has to think about the entire chapter. For instance, when it comes to panel layout, the beginning of a duel will typically have all rectangular panels. But as a character is backed into a corner and starts to get nervous, I'll use diagonal panels to reflect that. Then, when they have that "This is it!" recovery moment and take control of the situation, the panels will revert to rectangles. Of course, going overboard with that sort of thing can make it hard to read sometimes.

I can't think of many other manga artists who think about panel layout that way. So you'd say that those instincts come from a more general sense of design, rather than anything specific to manga?

TAKAHASHI: That's right. I see panel layout as a sort of puzzle. For example, when it comes to double-page spreads, the final scene the reader sees before turning the page has to connect to the next scene. So if I end with a panel where a character is drawing a card, the reader should almost be able to know what card was drawn before even turning the page. In that sense, the turning of the page and the drawing of the card are synchronized.

That sort of thinking works so well with the card game theme. I don't believe there were any other card game manga series at the time, but surely that "technique" already existed?

TAKAHASHI: As I drew, I found myself thinking, "What will the reader be thinking as she reads this page?" The technique came very naturally in that sense.

Drawing in order to delight the reader was something you thought about back during your childhood days. You mentioned enjoying making the people around you happy with your drawings.

TAKAHASHI: Right. Of course I enjoy creating manga myself, but more important than that is creating something that you know others will enjoy.

The illustrations you've done for art books also seem to have been drawn with the fans in mind.

RELATIONSHIP WITH ILLUSTRATING POST-SERIALIZATION

How did you color the illustrations you drew back during the early days of serialization?

TAKAHASHI: Before I had access to a copy machine, I would ink the originals with water-based ink and then color them directly. Once I got a copy machine, I would simply make copies of the rough drafts and color them with Copic brand pens.

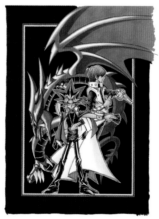

Yugi's hair changed from red to a sort of magenta, right?

TAKAHASHI: It's hard to do shadowing on pure red, so I had to change it. There's no black in pure red, but by adding blue to it I was able to add shadows more easily. Mixing red and blue naturally led to a purple shade.

How did you decide on overall color schemes?

TAKAHASHI: It's a shonen manga, so I tried to keep things exciting and varied. There are a number of base colors that I used. I'm particularly fond of the way that black backgrounds can really make characters pop.

It seems like your work, even back then, was polished to the point of appearing lustrous.

TAKAHASHI: No, I didn't have time for anything like that, and I wasn't using CG initially, so it was too difficult to show halation (*18). Halation occurs when an object is hit by strong light, and the ability to represent that in a drawing really makes a strong impact.

When it comes to illustration work, my strongest influence would have to be Drew Struzan (*19), who created the movie posters for "Star Wars". I've been a fan of his since before doing "Yu-Gi-Oh!", especially of the way he pulls off halation. His works always feature strong lighting, and that really brings his illustrations to life. Keeping his techniques in mind, I've tried working with halation lately in my own drawings. When using halation, I have a lot of fun figuring out where exactly light should be hitting.

There's one more fundamental difference between my early and present work. My illustrations back then were done with watercolors, so any and all coloring had to start with light colors. When colors progress from light to dark, one has to decide on the lighting from the start and gradually color in shadows. The "oil paint" that I use digitally now, on the other hand, starts dark and the lighting effects are added in at the end. Watercolors require light to come first; oil paints allow light to come last. This single difference has a tremendous effect on the overall feel of the work.

Which style do you personally prefer?

TAKAHASHI: When I was serialized, I wished that I had the time and knowledge to use digital oil paints. (laughs) Fundamentally, oil paintings - including landscapes and impressionist works - don't have outlines in them. But the illustrations of Drew Struzan and others are notable because they do begin with outlines. Once the outlines are there, they begin coloring with a high level of detail.

This method was pioneered by artists like Alphonse Mucha (*20) and the American master Norman Rockwell (*21), with Drew Struzan coming later. He started the trend of making movie posters in this way - with distinct outlines followed by detailed coloring.

Because impressionist paintings originally didn't have outlines, illustrators working with oils would produce fuzzy-looking work. But when you have a poster that's meant to advertise something, communicating that image is top priority, so poster artists began using outlines. That allows their works to catch the eye and leave an impact more easily.

During my days as a corporate logo designer, I too would begin with an outline and then start adding color, so I already understood the concept.

I'd like to ask about the illustrations you've made for art collections like this one. It seems like you put a lot of effort into lighting and skin textures.

TAKAHASHI: Women's skin and men's skin are very different things. With men you have more defined musculature, but with women the general goal is smoothness and softness.

In this illustration - "Magi Magi ☆ Magician Gal" - how did you decide on the orientation of the light source when doing her hat?

TAKAHASHI: In this illustration, you can imagine the light to be coming from wherever you want, really. In that sense, the lighting is sort of stylized. I wasn't trying to make it come from any single source or location. It's sort of open to interpretation.

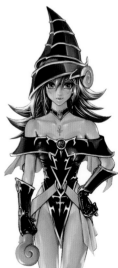

CREATING THE WORLDS OF "YU-GI-OH!"

How did you go about designing the characters and monsters for "GX" (*22) and "5D's" (*23)?

TAKAHASHI: The original "Yu-Gi-Oh!" series was a bit dark, so when it came time for "GX", I thought, "Let's make this one brighter!" It's set at a school, and the protagonist is a cheery, hot-blooded boy. He doesn't have a "dark" side, so he's pretty easy to read and empathize with.

So design-wise, he's more of a "standard" character?

TAKAHASHI: Yeah. That's why he has more of a - dare I say it - "normal" hairstyle, compared to Yugi's wild and spiky one. I remember telling myself, "Make it round!". (laughs) There's also the whole ranking system between the classes; I decided to make a simple story where the protagonist aimed to rise through the ranks. But it's hard to show growth with nothing but cheery characters who can overcome anything with that "I love dueling!" attitude. That's not enough to beat someone like the imposing Marik, from the original series. That wasn't enough for Jaden to reach his second year. So I went and wrote in the part about Supreme King Jaden, but that almost felt too dark...

But I think Jaden grew into a really good character after overcoming that. I'd even say he was the most appealing of the three protagonists in the movie (*24). It made me think, "I want to see Jaden's coming-of-age story!"

What was the concept behind "5D's"?

TAKAHASHI: Everyone's initial reaction was, "What's up with these 'riding duels'!?", but I really saw them as a necessity. When it came to duels in the series up to this point - whether at tournaments or in the school setting - the heroes and villains always had to be gathered in one place. Creating the "Duel Runner" vehicles made it possible for the protagonist to travel anywhere throughout his world. Characters could assemble pretty much anywhere. I feel like the world really opened up by introducing a long-distance travel method that the earlier parts of the series lacked.

Then there are the duels that take place while riding over the geoglyphs in the Dark Signers arc. That was something I was determined to include from the start. I actually pitched a story centered on the Nazca glyphs to Weekly Shonen Jump years ago, but it was rejected. That story began with a scene where five brave heroes with distinctive birthmarks are killed while fighting against a giant enemy atop the Nazca glyphs. Then those five are reborn, years later, with only those birthmarks to remind them of their past lives. They regain their memories bit by bit, meet each other, and eventually have a rematch with that original enemy.

Sounds like an awesome plot. Why was it rejected?

TAKAHASHI: I brought it to them as a one-shot. Unfortunately, the one-shot page limit ended right when the five leads ended up dying. (laughs)

The concept for the dragon marks in "5D's" came from that story, of course. At first I wanted to have the five Signers come from different countries and regions around the world and use their Duel Runners to gradually meet up with each other, but it would have taken at least half a year just for them to come together. (laughs)

The ideas in my original story only went as far as the geoglyphs in the Dark Signers arc, so the staff was responsible for crafting the story from that point forward. I was really pleased with the exciting stuff they came up with for that final segment.

So you were committed to riding duels from the start?

TAKAHASHI: The original plan was to have only Yusei and Jack having a riding duel in some sort of stadium, with an audience. So I was more surprised than anyone to see Tetsu Trudge dueling while riding a Duel Runner right from the start. (laughs) I just thought it was a really cool concept to have the protagonist ride a motorcycle as his duel monsters followed him from behind. At the time, there was no other anime or game doing anything like that.

When it comes to the monsters of "5D's", "Stardust Dragon" almost seems to be the mascot. How did you design that one?

TAKAHASHI: I wanted to make a dragon who could really "strike a pose", as they say in Kabuki. Dragons are generally categorized as either Western or Eastern, but Eastern dragons are often too long and thin and lack a sense of power, while Western dragons tend to be more like reptiles, crawling around on all fours. They've got these gentle, rounded shoulders. Whichever way you go, your dragon can't exactly puff out his chest. So instead of going with either an Eastern or Western theme, I designed a dragon with the physique of your average American comic superhero. One that could puff out that chest. You could even say it's anthropomorphic in that sense.

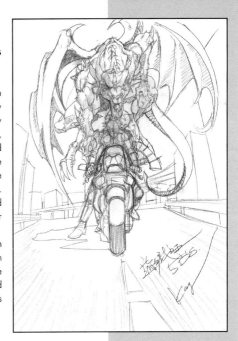

I thought it was really neat how "Black Rose Dragon" is based on the rose motif, yet is still clearly a dragon.

TAKAHASHI: My philosophy when designing dragons is essentially that any given theme or motif can work as long as the monsters share the most basic, recognizable attributes of dragons. The same goes for "Barrel Dragon". "Anything can become a dragon" is a central tenet of "Yu-Gi-Oh!". If I'd confined myself to the rigid idea that Western dragons must breathe fire and crawl around on all fours, making all these variations would have been very difficult.

Can we talk a little bit about "ZEXAL" (*25)?

TAKAHASHI: The creation of "ZEXAL" began with unique characters and a distinctive world that both laid the groundwork for the story, similar to how "GX" was done. This time around, too, the scriptwriters worked hard to create each character. I never could have imagined the role Bronk Stone would end up playing.

Right - he wound up being a main character.

TAKAHASHI: In the original plan, Bronk was just a nasty guy who bullied Yuma all the time, and Flip Turner was going to be his toadie. So I thought it was interesting when they defied expectations and became Yuma's good friends.

The monsters are also unique in a lot of interesting ways.

TAKAHASHI: "Terror-Byte" and some of the other "Number" monsters are done in CG, and that technology has really come a long way. It opens up the possibilities for some fun transformation gimmicks.

Speaking of gimmicks, "Chaos Number 39 Utopia Ray" has an extra arm besides his normal ones, and he uses that to draw the giant sword from his back. Transforming monsters like "Shooting Star Dragon" are also good examples; when thinking about how to design them in 3D, I take into account fun gimmicks that could be shown in the anime. So even when I'm coloring those rough designs, I find myself saying things like "This part will glow" or "This part will move like this". They're designed with motion in mind. A simple pencil drawing isn't enough when it comes to monsters that will eventually be animated.

I'd like to end by asking about any plans you have for the future.

TAKAHASHI: I don't intend to ever stop illustrating. Beyond that, I'd like to keep writing stories and maybe do a full-color manga. Either way, I hope people will continue to enjoy the things I draw.

Thank you for taking the time to do this interview!

***22 "GX":**

Full title: "Yu-Gi-Oh! GX". An anime aired by TV Tokyo on Saturday mornings at 7:30 from October 6th, 2004 to March 26th, 2008, with a total of 180 episodes. The school-based story follows protagonist Jaden Yuki. He's a terrible student, but he's cheery, he loves dueling, and he never backs down from a challenge.

***23 "5D's":**

Full title: "Yu-Gi-Oh! 5D's". An anime aired by TV Tokyo from April 2nd, 2008 to March 30th, 2011, with a total of 154 episodes. Set in the near future, the story follows the five Signers - each marked with a sign of the dragon - as they come together to defend New Domino City from forces that threaten it.

***24 Movie:**

"Yu-Gi-Oh!: Bonds Beyond Time" premiered in Japanese theaters on January 23rd, 2010. Made to celebrate the tenth anniversary of the anime series, the movie sees the protagonists of the first three series - Yugi Mutou, Jaden Yuki, and Yusei Fudo - transcend time and space in order to duel together.

***25 "ZEXAL":**

Full title: "Yu-Gi-Oh! ZEXAL". An anime aired by TV Tokyo from April 11th, 2011 to September 24th, 2012, with a total of 73 episodes. With his signature phrase "Feeling the flow!", duelist Yuma Tsukumo takes on every challenge he comes across. With the help of the mysterious spirit Astral, he aims to become a duel champion. The title comes from the word "zeal" being multiplied many times over (hence the "x" in the center).

CREATOR'S
COMMENTS

Here are Kazuki Takahashi's comments on the illustrations found on pages 6 through 75 in this book.

P006

"Blue Eyes White Dragon"'s OCG illustration. I initially struggled a lot with composition and tried all sorts of different poses.

P007

"Red Eyes Black Dragon"'s OCG illustration. I like how the flames and lava throw a red glow onto the dragon's black body.

P008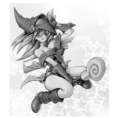

"Dark Magician Girl"'s OCG illustration. Making her nice and curvy was very important!

P010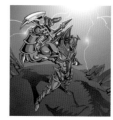

"Buster Blader"'s OCG illustration. The stylized fisheye perspective gives him an anime-esque look.

P011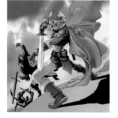

"Celtic Warrior" is a mainstay of Yugi's deck, so I gave him this cool pose for the OCG illustration.

P012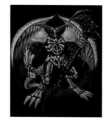

"Summoned Skull" renewal version. He initially had eyes on his face, but removing them ended up making him look much creepier.

P013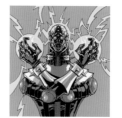

This is "Jinzo". He's a popular card for his ability to search for traps, so I tried to make his illustration really unique.

P014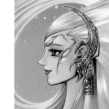

"Gyakutenno Megami" doesn't appear in any duels in the actual story, but I really wanted to draw an illustration of her.

P015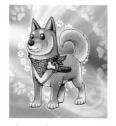

This was done purely on a personal whim. I turned my beloved dog Taro into an OCG card. Sorry, OCG fans.

P016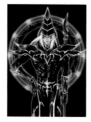

"Dark Magician"'s OCG illustration. He ended up being blue in the story, but the original image was more black.

P017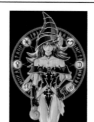

I drew this black-clad "Magician Girl" as a counterpart to "Dark Magician", but she wound up as the card "Magi Magi ☆ Magician Gal".

P018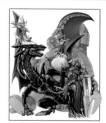

Monsters from Yugi's deck during his ceremonial duel against Atem.

P019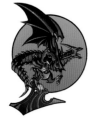

The illustration that went with the action figure of "Red Eyes Black Dragon", made by Good Smile Company.

P019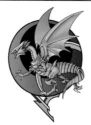

The illustration that went with the action figure of "Blue Eyes White Dragon", made by Good Smile Company.

P020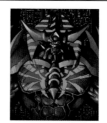

The imposing, original version of Obelisk that appears in ancient times in the story. The present-day Obelisk has changed in appearance due to the passing of the ages.

P021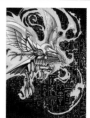

The card illustration for "The Winged Dragon of Ra" was originally based on a falcon motif.

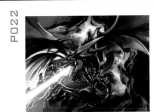

P022

The illustration of "Slifer the Sky Dragon" made for the OCG and this image collection. Here, we see him tearing through thunderheads as he is summoned.

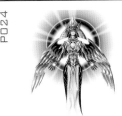

P024

"The Creator God of Light, Horakhty" binds the three god monsters. She symbolizes the light of the sun, maternal love, and peace on Earth.

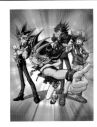

P026

The four protagonists in one big group shot. The youngest, Yuma, is sort of protected and surrounded by his elders. I feel like each of them really has his own distinct personality.

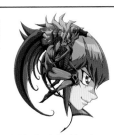

P027

Jaden and Yubel. Jaden is bright and cheery by nature, but I've drawn him kind of dark here...

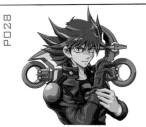

P028

I tried drawing Yusei and his Duel Runner. There's a rumor that Yusei's hairstyle is based on my bedhead. That rumor is true.

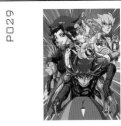

P029

A group shot of the protagonists of "5D's". Brighter, anime-style coloring really makes them pop.

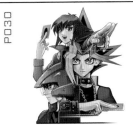

P030

The successive "Yu-Gi-Oh!" protagonists. Without a doubt, the one with the strongest pose is Yugi (Atem), so he's in the middle.

P031

Another shot of three "Yu-Gi-Oh!" protagonists. There's a rumor that Yugi's, Jaden's, and Yusei's hairstyles are representative of paper, rock, and scissors, respectively. That rumor is true.

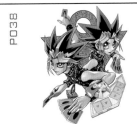

P032

Some say that the day "Yu-Gi-Oh!" started introducing aliens was the day I'd run out of good ideas. But Astral is a good character!

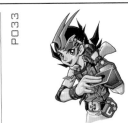

P033

I drew this illustration of Yuma for the cover of V-Jump, but the current anime version of Yuma really has a different feel to him. Well, this is how I originally envisioned him...

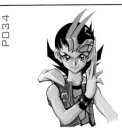

P034

Another early drawing of Yuma. This was done before the anime had started.

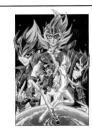

P035

An illustration of ZEXAL. His hairstyle is a fusion of Yuma's and Astral's. I even impressed myself when I came up with his hairstyle.

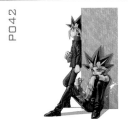

P038

An illustration of Yugi and Atem together. I was really glad that I managed to make Yugi pose so gallantly as a duelist for the cover of this collection.

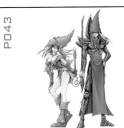

P039

An illustration made just for this collection. I tried to show the board game theme of the RPG arc. You've also got Bakura being controlled by Dark Bakura and Zorc.

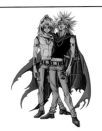

P040

Atem and Joey are headed for Duelist Kingdom, and they inspire in each other the will to fight on.

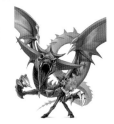

P041

The Kaiba brothers. I was happy with Seto's arrogant pose and Mokuba's proud gaze.

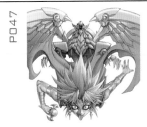

P042

This is an illustration I made for the opening of my home page. The distance between Atem and the Millennium Puzzle symbolizes the fact that he'll soon be parting ways with Yugi.

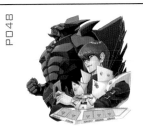

P043

"Dark Magician" and his apprentice, "Magician Girl". I really put a lot of care into them, given how faithfully they serve Yugi and Atem.

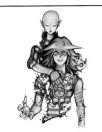

P044

Marik and Dark Marik represent a wickedly dangerous relationship born of codependency and a split personality. They inspire bloodlust in each other and violently lash out against everyone else.

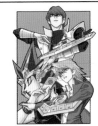

P046

Atem and "Slifer". Slifer's design is based on Eastern dragons. If I had to choose, I think Western dragons are easier to draw.

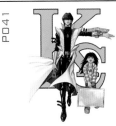

P047

An illustration of "The Winged Dragon of Ra" and Dark Marik, done for the Bunko publication. Here, it almost looks like he's just making a funny face, as opposed to being completely insane.

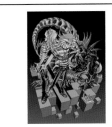

P048

Kaiba and "Obelisk the Tormentor". I modified and added to the earlier version of this illustration. Even Kaiba's expression is slightly different.

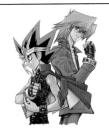

P049

Dark Bakura and his "Dark Necrofear". Looking at this illustration, where he's all wreathed in darkness... it still gives me the chills.

P050

In this shot of Atem, Kaiba, and Joey, each duelist is done slightly differently.

P051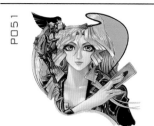

Mai Kujaku and her "Harpie Lady". Do whips and bondage really have any place in a shonen manga? ... No, no! Of course not!

P052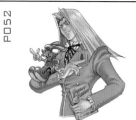

A duo shot of Maximillion Pegasus and his beloved "Toon".

P053

An illustration just for this book. "Yugi" implies "purity", but it looks like the artist wasn't aware of that…

P056

The illustration of Yugi and Atem for the cover of volume 1 of the Bunko publication. I almost reconsidered it when someone pointed out that this essentially spoils the end of the series.

P057

An illustration portraying an average day off for Yugi and Joey. Having each of them looking for a place to go while in the middle of a crosswalk brought back memories of being 17.

P058

Yugi and friends smash through the barriers of "Death-T" while Kaiba waits at the end. The logo is designed to look like a high-tech gate.

P059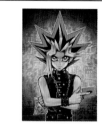

The illustration for the cover of volume 2 of the Bunko publication. This was actually the first illustration I did digitally. From that point on, I started working solely with CG and never looked back.

P060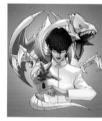

Seto Kaiba and his "Blue Eyes White Dragon" from the "Death-T" arc. Back then, Kaiba was a mean and petty guy, and I tried to show that with his expression.

P061

Dark Bakura during the "RPG arc". There aren't many characters out there who fight using dice, and I'm actually a fan of non-card games as well.

P062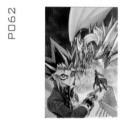

The scene from the "Duelist Kingdom" arc where Yugi (Atem) stands against Kaiba, who is elated after summoning his "Blue Eyes Ultimate Dragon".

P063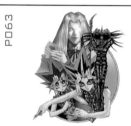

The final duel of Duelist Kingdom, against Pegasus. His ability allows him to read the hearts of his opponents, so the two Yugis have to cooperate to challenge him.

P064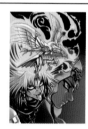

Dark Marik and Ishizu, with "Ra" added on top. I was having a lot of fun drawing Dark Marik's insane expressions at the time. I daresay he's holding back a little in this one.

P065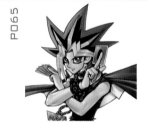

An illustration for the cover of V-Jump. It was featured on my home page in a video clip about drawing for a limited time.

P066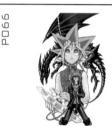

Yugi's duel against the brainwashed Joey. I tried to capture the do-or-die feeling and surrounded the two with "Red Eyes Black Dragon"'s body.

P067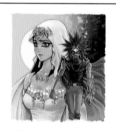

An illustration of Ishizu and Dark Marik for Bunko. The light of the sun and the encroaching shadows show the contrast between these two characters.

P068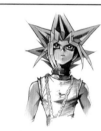

When my home page was complete, I drew Yugi for the first time in a while.

P069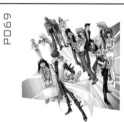

The goal here was to represent the finale of the "Battle City" arc. Only Kaiba stands outside the border of the Millennium Puzzle.

P070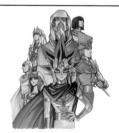

Atem and his priests in the "Millennium World" arc. The idea that a ritual from ancient Egypt turned into a card game is basically the cornerstone of all of "Yu-Gi-Oh!".

P071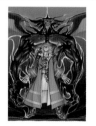

Thief King Bakura and Diabound, the evil force driving his heart to darkness. I actually have a lot of fun drawing really, really evil monsters.

P072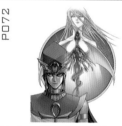

Priest Seto and Kisara, the vessel of Blue Eyes White Dragon. This illustration shows how present-day Kaiba is driven by the karma of his past life.

P073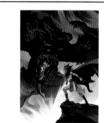

Atem bravely stands against Zorc. Zorc's strongest-ever form is terrifying to behold, but the pharaoh stares him down without fear.

P074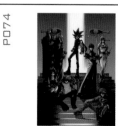

I poured my heart into this illustration, meant as a symbol of gratitude for all the fans who've supported "Yu-Gi-Oh!" over the years. Thank you, really.

P075

An illustration for the cover of the final Bunko publication. The background of the entire volume was made white just for this image.

P076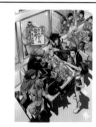

Finally, we have an illustration of Yugi and friends enjoying everyday life. Note that Yugi is without the Millennium Puzzle. This represents his carefree days after parting with Atem for good.

IT'S ALREADY BEEN SEVEN WHOLE YEARS
SINCE SERIALIZATION ENDED, AND NOW
WE'VE FINALLY GOT A BOOK WITH ALL THESE
ILLUSTRATIONS. NOTHING MAKES ME HAPPIER
THAN THINKING OF ALL THE FANS WHO'VE
SUPPORTED "YU-GI-OH!" GETTING TO RELIVE
THEIR MEMORIES OF THE SERIES THROUGH
THE CHARACTERS IN THIS BOOK. I ONLY
HOPE TO CONTINUE IMPROVING SO I CAN
KEEP CREATING WORK THAT I'M PROUD TO
CALL "DUEL ART".

THANK YOU SO MUCH!

NOVEMBER 3RD, 2011
KAZUKI TAKAHASHI

連載終了から早や 7年の月日が経ち.
ようやく 画集という 最高の形で
僕のイラストを まとめる事が 出来ました.
遊☆戯☆王 という作品を支えて下さった皆さんが
画集を手に, ここに 描かれた キャラクター達を
想い出してくれたら. これ以上婚しい事はありません.
今後も DUEL ART のタイトルに恥じぬより.
さらに 画力が 上達するより.
これからも 絵を 描いていきたいと思います.

本当に ありがとう ございました!

2011.11.3.仕事場にて.

高橋和希

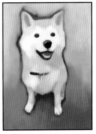

PHOTO OF THE
AUTHOR

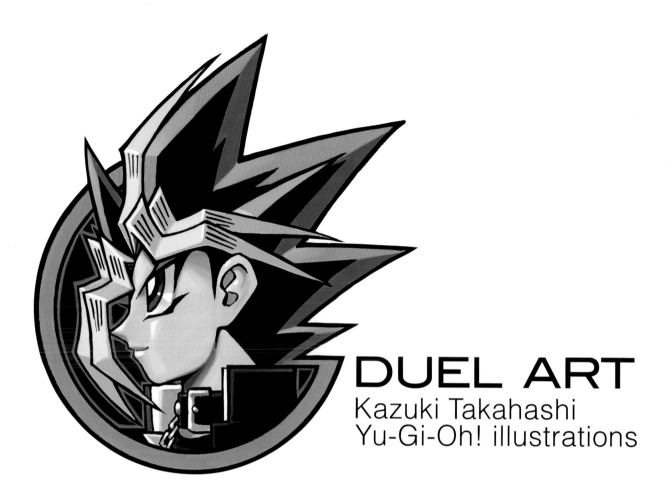

DUEL ART
Kazuki Takahashi
Yu-Gi-Oh! illustrations

ENGLISH EDITION CREDITS

English Translation
CALEB D. COOK

Copy Editing
ASH PAULSEN

Layout and Design Adaptation
MATT MOYLAN

UDON STAFF
Chief of Operations: ERIK KO
Director of Publishing: MATT MOYLAN
Senior Editor: ASH PAULSEN
Senior Producer: LONG VO
VP of Sales: JOHN SHABLESKI
Production Manager: JANICE LEUNG
Marketing Manager: JENNY MYUNG
Japanese Liaison: STEVEN CUMMINGS

JAPANESE EDITION CREDITS

企画・構成　内田正宏・渡邊祐仁・岡崎一彦・内海　謙 (ウェッジホールディングス)
デザイン　阿部亮爾・[BGS制作部] 宮澤俊介・橋本康代 (バナナグローブスタジオ)
DTP　関　光志・宮川央士 (ビーワークス)
協力　友永晃浩 (スタジオ・ダイス)

Published by UDON Entertainment Corp., 118 Tower Hill Road, C1,
PO Box 20008, Richmond Hill, Ontario, L4K 0K0 CANADA

www.UDONentertainment.com

First Printing: May 2015
Second Printing: March 2017
ISBN-13: 978-1-927925-41-6
ISBN-10: 1-927925-41-X

Printed in Hong Kong